# SUNSET  PARK

## ON U.S. RT. 1 BETWEEN WEST GROVE AND OXFORD

**SUNDAY, JUNE 22**

Carl Smith, Columbia Recording
Artist from Nashville, Tenn.

**Steryl Sauble**
& the RHYTHM KINGS

Alex, Ola Belle & the New River Boys & Girls

**SUNDAY, JUNE**

K... Wells
& the J... SHOW

Alex, Ola ... Boys & Girls

**FRIDAY, J...**

"The Ke... Wonder"

ANNUAL 5 STR... BANJO CONTEST

Prize: "Scruggs ...odel Vega Banjo"

Alex, Ola Belle & the New River Boys & Girl

**SUNDAY, JULY 6**

The Bill Anderson Show

WITH JIMMY GATELY & JAN HOWARD
WITH MAGIC & ILLUSIONS

Alex, Ola Belle & the New River Boys & Girls

**SUNDAY, JULY 13**

The Stonemans
SINGIN' SWINGIN' AND STOMPIN'

**Warren Mercer**
& the ROYAL RAMBLERS

Alex, Ola Belle & the New River Boys & Girls

**SUNDAY, JULY 20**

Bill Monroe
& the BLUE GRASS BOYS

Ale...

ADMISSION $1.50, TAX INC...

---

COMING ATTRACTIONS!!          NEW RIVER RANCH!!!

AUG. 19th...          OSBORNE BROTHERS!!

---

BOBBY BROWN'S

*New River Ranch*

US Rt. 1 - Rising Sun, Md.

Presents World Famous

*Eddy Arnold*

SUNDAY   JULY 29, 1962

3 Shows Rain or Shine

2 p.m.   4 p.m.   6:30 p.m.

Adult Adm. - $1.50
Children Under 12 Free

Nº 1395

---

# PURE
# COUNTRY

# PURE COUNTRY

*The Leon Kagarise Archives, 1961-1971*

Foreword by Robert Gordon
Introduction and Text by Eddie Dean

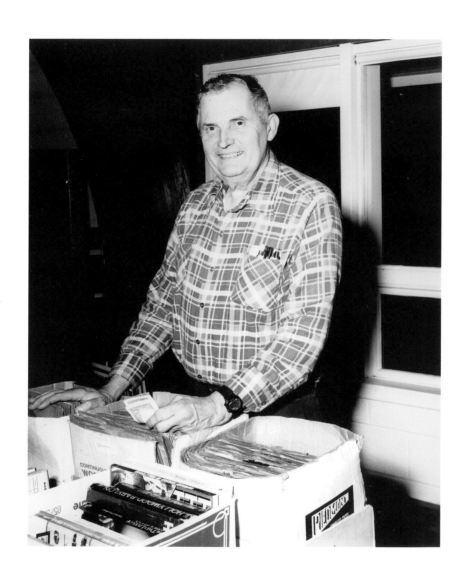

*In memorium*
*Leon Kagarise*
*1937–2008*

# ❧TABLE OF CONTENTS❧

Sincerely
Bette Davis

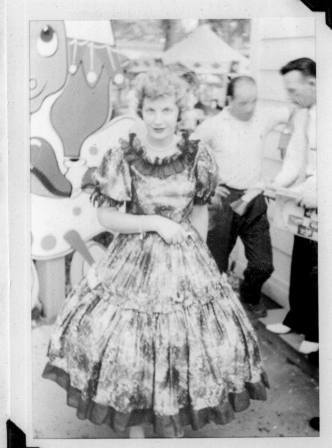

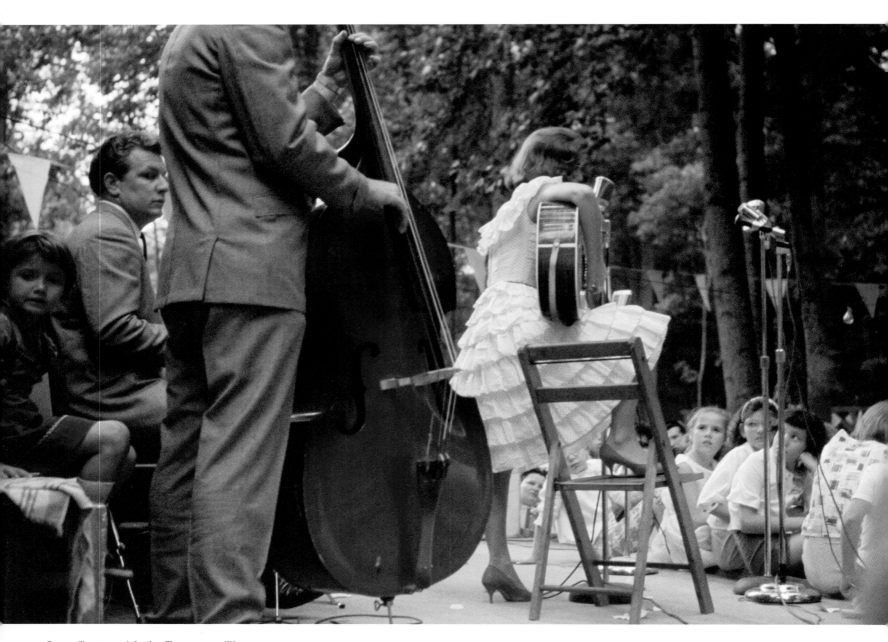

*June Carter with the Tennessee Three*
*NEW RIVER RANCH,*
*Rising Sun, Maryland*
*1962*

# ❖FOREWORD❖

*BY ROBERT GORDON AND TARA McADAMS*

The camera blinks, and time seems to stand still. But time never slows, never halts, always changes. It's the movement of light caught in the camera's mechanics that becomes fixed. The moment sets, becomes tangible, and is offered to the future.

1958 to 1968 was a period of change, when U.S. society was reconfiguring itself radically. On the east coast, between Washington, D.C. and New York City, in the midst of the most radical changes, there were two country music hideaways where "progress" seemed not to encroach. One was a little holler outside of Baltimore called the New River Ranch, and the other was a farm nestled in the verdant Amish country east of Philadelphia, Sunset Park. While superhighways were connecting towns to cities and cities to a sprawling metroplex, a wall of trees and tradition protected these sanctuaries where folks gathered to hear country music played like it always had been played. And unlike it was being heard on the radio.

It was as if these two venues had flowed north from Appalachia. Within the dense urban populations, there were those who treasured country music's simplicities, either hearkening to their own past or romanticizing what the music evoked as an alternative to the increasingly restive world around them. Though open to the public, both New River Ranch and Sunset Park were like secret enclaves, the same crowd returning over and over. Patrons would drive through the trees, pay a dollar for the carload and check their present tense at the entrance. Out came the picnic suppers, the kids ran loose, and anyone could be up close and personal with some of the biggest names in country music.

But for the odd recording and the apocryphal stories, this once-thriving scene would have been lost. Fortunately, one of the parishioners of these temples to timelessness was an audio engineer from Baltimore named Leon Kagarise. A compulsive collector

and technologically adroit, he was a fan who wanted to retain the moment. To touch it again. Kagarise made crisp audio recordings, and he preserved the scene with several hundred color slides.

Country music was undergoing a seismic change when Leon took his first photograph in '58. Several years earlier, Sun Records in Memphis had unleashed a new take on country music, hopping it up with a dose of blues and rhythm. Now, we see this new style as rock and roll, but back then the new sound was part of the country world. The Grand Ole Opry invited Elvis to perform in 1954. And did not invite him back.

The trend that came to dominate country music was a response to the quake from Memphis. As one force pushed, the other pulled. Nashville producer Owen Bradley replaced fiddles and steel guitars with string and vocal sections, making country music smoother and less identifiable as a genre. Producer Chet Atkins followed suit, their stylistic changes soon dominating Nashville's output. The result was that Ernest Tubb still drawled like the Texan he was, but the cactus and tumbleweed in his accompaniment were replaced by smooth cotton sheets chilled in air conditioning. Country singers who adapted to the lush orchestrations saw an increase in sales and popularity: Jim Reeves, Patsy Cline, Loretta Lynn, and Conway Twitty were no longer just singers, they became *recording artists*. Producers assumed a new power, creating studio sounds that had little or no relation to an artist's stage show. If the record could not be reproduced on stage, so be it; in fact, many artists had no interest in ever reproducing the slick, controlled contrivances—the "recording art"—ever again. The studio recordings generated record sales, but when the songs became part of the stage repertoire, they were adapted to fit the more traditional instrumental lineup of the performer's traveling bands.

What Leon Kagarise saw and heard at the New River Ranch and at Sunset Park bypassed these fault lines in the country music industry. Exiting the superhighway's ramp, stars and fans preserved a bucolic moment of community that was increasingly hard to find beyond the woods that surrounded

the park. As seen in Leon's photographs, the performers stepped to the stage from among the audience of their peers. At New River Ranch, there was no backstage to speak of—a storage area for the bass fiddle was about it. With no restricted or exclusive artist's area, most performers awaited their stage call walking among the crowds, accepting an invitation to sit and eat, share a smoke, maybe pick a little during an intermission. Many in the audience, and not just the kids, are seen wearing outfits like their heroes and it can be hard to tell who's about to take the stage. A part of the audience that also happens to perform, the stars are burping up barbecue chicken, swatting at the bugs, sweating in the heat like civilians. The divide between the performer and the audience existed only when music was being made and one faced the other.

A great deal of the photographs' charm is the simplicity of what's captured. Nashville had been polishing its country music gems, the high gloss of the lush production values making country music palatable to a wider demographic. But there is no gloss here, just the unvarnished wood of picnic tables and wide planks for seating. Icons like Johnny Cash and the Louvin Brothers are presented plainly, almost baldly, as the line between the famed and familiar recedes.

You can almost touch the intimacy and authenticity in the pictures. There's no dramatic lighting, no sense of the hermetic studio. Look how many artists have something in their hands—a cigarette, a pen, a disposable drinking cup. Sometimes their hair's a mess, sometimes a shoulder strap has strayed. Some are posed, but it's the way you pose your daughter before the prom, or your uncle at the bar mitzvah; there's none of that contrived "genuineness" of professional shoots. June Carter—fantastic from a rear angle, a frothy dress, her shoulders squared just so to deliver the cornpone humor. The way Skeeter Davis clutches a stuffed doll, you can tell she's not just sending a message of thanks to the fan she's speaking with, she's feeling the love from them both.

Up front was the place to be at these shows. It's a wonder Leon could get the camera high enough to take a picture when Ernest Tubb played; it's the Matterhorn of ten gallon headgear. And when Johnny Cash is on stage, and the

Carters too—people got early to the stage's edge and hung on like Sherpas until it was time to go. (In one, June Carter has her foot on a chair to help prop up her guitar; the men must have fought to be in front for that. What June lacked in pipes, she made up for in personality; she knew how to sell a song.)

Though a star may be at the center of Leon's photographs, the eye is often drawn to the periphery. In one shot, Hattie Stoneman is seated on a bed, playing the guitar, while a pixiesh child leans nearby, her white knee socks in perfect contrast to Ms. Stoneman's very artificial wig. Wires run like snakes down the wall behind them, and the mood of the moment and the decade is captured perfectly.

Not only Leon's photographs but also his recordings—he was an audio engineer before he was a photographer—transport us to this lost time. With a single mic, he puts us center stage, on the stage, among country stars who play country music in the country for country people. It's a sound, a world, that has largely eluded posterity. Record labels were not making live recordings of country music at the time— the technology in the studio was too enormous to move, and portable recording had to be dismissed: If anyone could do it, then what was the purpose of a recording company?

In the middle of the 1960s, the Beatles came to America. By the end of the decade, they couldn't perform live anymore because their fans were too rabid. Elvis had returned to performing live, playing in sports arenas on sound systems built for the announcer's play-by-play. And country music, for the most part, got swept up in the new Nashville sound, the cosmopolitan swank that was the natural conclusion of what Owen Bradley had begun. All of these musical "moments" have been documented and analyzed to death.

Which brings us to an underlying power of Kagarise's photographs. These are a collection of images that shouldn't be here. These are not a performance on Ed Sullivan, a press clipping, a photo op. No one showed up for the express purpose of having his or her picture made. These are the visual equivalent of the stories your grandmother told you—about how she always sat on the stage when Ernest

Tubb played, or the time that Mother Maybelle sewed a button on her shirt before she took to the stage. There's a homeliness and a hominess to these images that belong to the realm of oral history, carried down through family lore. We're drawn in by the deserted stage, not much larger than a storage shed, with rows of roughhewn seating that ask us to sit down. We are compelled—not to ogle or admire, but to participate when we view these pictures.

Leon Kagarise's photographs resuscitate a world that's been washed away by technology, erased and replaced by managers and lawyers, contracts and corporations. If Kagarise's world weren't presented so simply, it would be mythic. Story telling has been gently but inexorably demoted as an art form, marginalized to Public Radio and children's specials. Ephemeral in nature, ephemeral like nature, storytelling has a dynamism born of the equal demands that it places on the listener and the teller. Kagarise's images preserve a very particular and quickly vanishing stage of country music. The photographs are unaffected, unassuming, the surroundings immediate, and by looking at them, we engage. The musicians, the audience, the cars and the trees—they all fill in the narrative. Like Leon Kagarise, we fall in love.

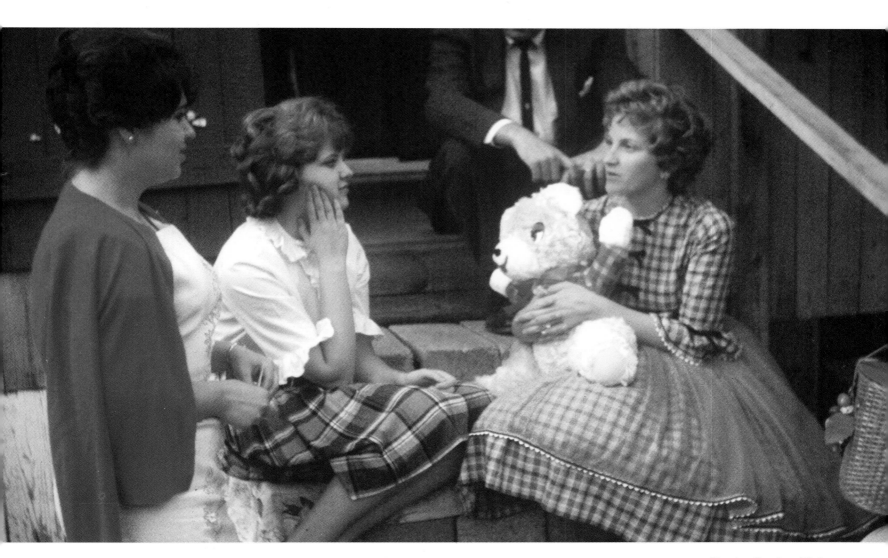

*Skeeter Davis with fans*
*NEW RIVER RANCH*
*1961*

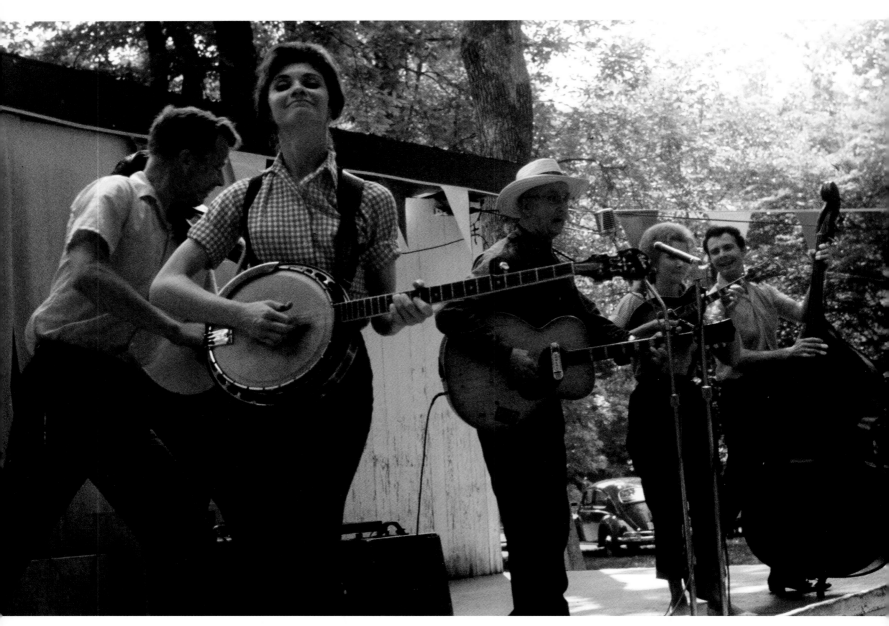

*The Stonemans (Scotty, Roni, Pop, Donna, Jimmy)*
*NEW RIVER RANCH*
*Rising Sun, Maryland,*
*1963*

# ❖A HAPPY CRY❖

## THE MAKINGS OF A COUNTRY-MUSIC CHRONICLER
*BY EDDIE DEAN*

Leon Kagarise came from the country but he did not come from a country-music family.

When Leon was barely 10, his father, an electronics engineer, came home with a second-hand Apex cathedral radio, a present for his precocious son who had inherited the knack for fixing gadgets and unlocking the mysteries of mechanical things. This radio, broken down though it was, was a monument to the golden age of post-war technology, when even the most modern gadgets could be repaired with a pocket screwdriver and good old American know-how instead of thrown into the trash.

It didn't take long for Leon to probe the wiry innards behind the walnut-backed console and bring the Apex back to life. What his proud father did not know at the time was that his son had discovered a soul in his resurrected radio in the form of country music. In the late-night hours, while his parents slept, Leon turned the dial to country stations, where the shy, timid boy found a world he could lose himself in. The songs of lonesome hillbillies and lovesick honky-tonkers spoke to his heart and made him feel alive, even as his parents, devout members of the Church of the Brethren, frowned on his infatuation.

Years later, in the late '50s when Leon began attending shows at country-music parks along the Mason-Dixon Line near his home, he found the flesh-and-blood manifestation of his new passion. Here were the country stars of his radio dreams playing country music for country people in the countryside. He began to document this vision come to life in field recordings and photographs. It was a weekend hobby, this special project of his, to scratch the itch of a growing obsession. He had no thoughts of commercial gain or posterity. He was driven by the compulsive desire to somehow make the precious moments he experienced there last forever.

Standing in the midst of a show at a country-music park, close by the stage, with the music ringing in his ears and his favorite stars performing in all their spangled glory, Leon would often become so overcome with emotion that he would sob with joy.

> *When the music got really good, I would*
> *just break down and cry. I couldn't help*
> *myself. I would try not to let anyone see*
> *me because I'm a man and everyone knows*
> *men aren't supposed to cry, so I would try*
> *to keep it to myself. It wasn't the weepers*
> *or the slow sad songs that got to me. It was*
> *the real high-energy, fast bluegrass songs*
> *like the Stonemans did. Those are the*
> *kind that grabbed me and just tore me up*
> *and wrung me out like a rag. To be there,*
> *with the sounds and the smells and all the*
> *people loving the music so much and I'm*
> *standing six feet from the stage and the band*
> *is playing and the music is so fantastic.*
> *It all got very emotional for me. It was a*
> *happy cry, not a sad cry, but I was just*
> *overwhelmed by it all.*

Wordsworth famously said poetry is emotion recollected in tranquility. It is fortunate for us that Leon's emotions spurred him on to preserve such moments. By the time of his death, there were more than 750 color slides, many of which are published here for the first time after more than a half-century hidden from the public eye. They are eloquent and enduring—and yes, poetic—expressions of one man's lifelong love affair with classic country music, the performers who made it and the people who, like Leon, cherished it so dearly.

From the start, country music was a strictly personal affair for Leon. Like so many others in the war years, his father had left his rural roots behind to find work in Baltimore, but he had no love for the hillbilly music that the migrants brought with them. Mr. Kagarise had grown up in the corn-belt area of central Pennsylvania in a tiny town of Martinsburg,

near the railroad hub of Altoona. Upon reaching manhood, he lost out to a brother for the inheritance of the family farm. So, with a young wife and three sons including Leon in tow, he took an electronics correspondence course and got a job at the Bendix Radio Corporation in Baltimore, where he worked for the next 35 years.

The Towson suburb on the outskirts of town where the Kagarises settled was far from the bluegrass bars and beer joints of Baltimore's booming country-music scene, but the Apex cathedral radio brought the sounds of that world to Leon, and it changed him for life. He wasn't allowed to have the radio in his bedroom, so he retreated to the basement, where he rigged an antennae outside so he could pick up WCKY out of Cincinnati. Wayne Raney's night show beamed clear-channel, a wild stampede of crying fiddles and ringing banjos and whining steel guitars. Raney talked like a hillbilly and sold $1.99 mail-order harmonicas. Leon was captivated.

> *As soon as I heard country music on WCKY,*
> *I fell in love with it, and that love never*
> *left. My parents listened to big-band music*
> *like Glen Miller, especially my mom. She*
> *thought country music was low-class. To her*
> *it meant a hillbilly with straw in his mouth*
> *and tattered hat, bare feet and no education.*
> *That's where she was coming from. So she*
> *would get very angry. She would say, 'Turn*
> *that stuff off or else.' But I loved it too much.*
> *I said to myself, 'I don't care what you think.*
> *I'm going to listen to this stuff." And I did.*
> *And the more I listened to it, the more I*
> *liked it.*

This act of defiance did not develop into the usual adolescent rebellion. As Leon reached his teen years and the rock revolution exploded around him, he stayed true to his boyhood crush on country. His peers flocked to the sock hops and danced on The Buddy Dean TV show and rocked around the clock, while Leon remained glued to his radio, listening to hillbilly music.

*I was never a rebel-rouser of any kind. I had to keep my love of country music to myself, because if my mom caught me listening to it, she'd make me turn it off. She thought it was junk.*

Leon Kagarise
BALTIMORE, MD
late 1950s

# AMPEX 960

### STEREOPHONIC                    RECORDER/REPRODUCER

**Plays both 2-track and 4-track tapes**

RECORDS STEREO
OR MONOPHONIC

ABOVE--960 PORTABLE STEREO
RECORDER/REPRODUCER

BELOW--MODEL 2560 PORTABLE
STEREO SYSTEM CONSISTING OF
960 AND PAIR OF 2010
AMPLIFIER-SPEAKERS

## Stereo Portable PLUS!

Guiding the Ampex engineers who created the 960 was a dual objective—
that of building a machine which was not only a superb example of
engineering skill, but one which would also offer its user
a range of capabilities far exceeding that of any other recorder made today.
The result was not merely an improved stereo recorder,
but *an entirely new concept* in home entertainment.
The STEREO 960 fits into family life in literally dozens of ways, contributing many
tangible benefits in musical, educational and recreational fun. You'll use it to keep up the
family correspondence by sending "letters in sound", to tape stereo programs off the air,
to preserve your best monaural and stereo discs on tape, and to acquire new musical and language skills.
You'll have endless fun exploring the 960's many fascinating recording capabilities, including
sound-on-sound, echo chamber effects, and other advanced techniques.

AMPEX

Even if he'd wanted to join the fun, his parents wouldn't have permitted it. They were members of the Church of the Brethren, a denomination he simply called "an old-fashioned Bible church." Their local congregation wasn't big on music of any sort and the congregation nearly had a split over whether to allow a piano in worship services. Leon was a dutiful son who obeyed his parents and did his best to hide his infatuation.

> *I was a very tame child. I was never a rebel-rouser of any kind. I wasn't very social at all, and so I wasn't very successful with girls, because my folks were so strict. They pretty much discouraged dating, and I was never allowed to go to parties. So while the other kids were out running around and partying, I was home doing my thing, listening to country music and fixing radios.*

Leon's isolation only stoked his dual devotions. He soon advanced beyond building crystal radio sets and hi-fi consoles to more adventurous tinkering, especially after his brother Glen brought home a wire recorder and let Leon listen to his recorded voice say the words, "Hello there."

He borrowed one of the new reel-to-reel recorders that utilized magnetic tape and began recording his favorite country radio programs and TV shows, like the *Don Owens Jamboree* from Washington DC, with the help of his father. "He didn't care what I was taping, he just wanted to help me. We'd go straight into the circuit with the shielded cable, because back then TVs didn't have a "Record" output. Se we hooked up our shielded cable to the cathode follower and got beautiful recordings right off the air."

One month after graduation from Towson High School in 1958, Leon got his dream job at the High Fidelity House,

Baltimore's biggest and best high-end stereo retailer. Ensconced amongst the gadgetry of the High Fidelity House, Leon was in his element, and he soon became the Wonder Boy of the installer-service department, summoned by the area's wealthiest citizens into their homes so they might partake their allotted portion of the Stereophonic Age.

But the lifestyles of the rich and famous held no real temptation for Leon. He'd already found his own version of the American dream, peopled by humbler folk, the "friends and neighbors" who thronged the country-music parks just an hour's drive away. Even as he kept his day job at the High Fidelity House, he found his life's work at New River Ranch and Sunset Park, where he humbly served without pay or praise as the recording angel of this earthly paradise--and he had some of the best equipment then available to help him fulfill his destiny.

What he found at these parks weren't friends, really. He was too shy to make friends. (Years later, when Leon re-visited Sunset park, the owner who'd run the place for four decades didn't remember Leon at all.) What Leon did find there was a community, an extended family where he felt at home. It was a bonafide underground scene, these farmers and factory workers and displaced Southerners who'd migrated like his dad did for jobs. Some worked at the munitions plant

*New River Ranch, Rising Sun, Maryland, Late 1950s*

in Elkton, MD, or at the mushroom farms near Kennett Square PA or at the Western Electric plant or Bethlehem Steel in Baltimore. They were hungry not only for work but for the old-time string band music of their native regions.

Both Sunset Park and New River Ranch were humble meccas as befitting their time and place. Open-air wooden stages, rows of sawmill planks on cinderblocks for seats and day's entertainment for a thousand or so faithful ready to bust loose after church. There were carnival booths and concession stands for the youngsters.

For the musicians, these country-music parks offered a pit stop in between the grind of low-lit honky tonks and beer joints and the glare of the Grand Ole Opry. Many made the 750-mile drive from Nashville after a Saturday night appearance, rolling in with just enough time to knock off their whiskers in the men's room and hit the stage.

All the biggest stars played here, Hank Williams, Roy Acuff, Ernest Tubb, Patsy Cline, Johnnny Cash, George Jones. And there were bluegrass greats that Leon loved most, Bill Monroe, the Stanley Brothers, Flatt & Scruggs, the Stoneman

Family, as well as hundreds of obscure acts whose biggest taste of fame was earning a billing on a poster for a show at Sunset Park or New River Ranch. Whether greenhorns on their way up, or grayhairs on their way down, they were always welcome out here in the sticks.

Even as the '60s wore on, and country records became slick and larded with orchestral arrangements and background choirs and session hacks, the shows at these parks celebrated the music in all its raw, pristine beauty. They became ever more crucial gigs for traditional performers who couldn't get airplay, the ones who toured with their own tight, cracker-jack bands that shunned electric amps and other modern frills, with singers harmonizing around a single microphone. Old-time country music done the old-time way. That's the way the crowd liked it and it wasn't uncommon for hecklers to jeer acts that featured electric bass or drum sets. Acoustic music didn't get more hardcore than this—right off the back porch and straight from the hollow—presented without affectation, an unadorned rural sound. Fans like Leon discovered that even if real country music wasn't on the radio, it was alive and well at out-of-the-way outposts like Sunset Park and New River Ranch.

> *This is where you saw the REAL show.*
> *They weren't afraid to do the songs that*
> *weren't as well known. The audience would*
> *ask for ones the stars hadn't done in years*
> *and they'd do them. And there'd be people*
> *crying because the songs meant so much*
> *to them.*

Leon spent the next decade chronicling what he saw and heard, lugging his 50-pound Ampex reel-to reel tape recorder and Electro-Voice microphone. Leon made pristine recordings of entire shows in an era when live recordings of hillbilly music were rare as hen's teeth. Records were made in studios in Nashville, not in the Godforsaken woods in 100-degree heat under a tin-roofed stage. So nobody paid Leon any mind as he stood by the stage bent over his equipment as quiet and reverential as an altar boy. With his massive headphones planted on his head, Leon could have been an alien from outer space, and to many of the Mennonite kids he probably seemed just that. But he had a higher purpose, and he didn't care what anybody thought of his mission.

> *I just wanted to save the moment, as much*
> *as I could anyhow. I was trying in my own*
> *little way to stop time. I loved the country*
> *stars and their music so much. I didn't want*
> *it to change or ever go away.*

He taped hours and hours of concerts, complete with between-songs banter and cornball comedy routines and performers hawking their wares from the stage. The recordings capture the informal atmosphere of the parks and the artists at the peak of their craft, unbeholden to commercial trends. Together with his pristine recordings of hundreds of live country television and radio shows, his collection would eventually amass some 4,000 hours of recordings.

As important as the tapes are, they are only part of the chronicle. While his Ampex machine was running, Leon roamed the grounds of the parks with his Zeiss Ikon 35mm camera, taking photos of onstage action and offstage downtime. He snapped candid photos of the stars, not only in performance but relaxing in the crowd. The result, more than 700 color slides, is more than the labor of love of an obsessed fan, It is a vital document of a part of rural America in its last full bloom.

Here was Hank Snow in dark shades, resplendent in gold-burnished turquoise down to the tips of his Nudie boots and topped with enough pomade to grease an 18-wheeler; West Virginia fiddler Stoney Cooper in a blinding white suit like a campground preacher gone uptown, with his wife Wilma Lee in matching dress and high heels, both holding their autograph pens, proud as newlyweds even though they'd been married for 25 years; and Kitty Wells, the Queen of Country Music, holding court in pearls and a sky-blue gingham dress, blessing the fans below from a stairway backstage at Sunset.

*Jimmy Martin and Fan*
SUNSET PARK, 1968

As with his recordings, Leon the photographer was a compulsive perfectionist, obsessed with getting the most faithful reproduction of the moment. Shooting with black-and-white film like the rest of the fans with their big box cameras never occurred to him. Despite its exorbitant (for Leon) price, he shot color slides almost exclusively. This would distinguish his work not only from other country fans of the period, but from professionals as well. Of the handful of published images of outdoor music parks during this golden era of country music, nearly all are in black and white.

The clarity of Leon's photos combined with the super-saturated color lend an Oz-like radiance to Leon's subjects. Details like the aqua-tinted flower-pattern on Ernest Tubb's boots, the burnished gold bolo tie of Pop Stoneman, and the radiant shine of June Carter's flowing tresses would have been lost in a black-and-white print.

But the candid portraits are only part of Leon's wide-ranging collection. His sharp eye turned to the stage with no less insight into what made these performers set post-war country folk on fire with their talent and charisma. Here was a young

Johnny Cash, taut and wired as an electrical conductor; manic showman Scotty Stoneman dripping sweat onto his battered fiddle; Ira and Charlie Louvin stepping as one into a song as only brothers can do. And Leon gave the sidemen their due as well, like the Stanley Brothers' cross-picking guitarist George Shuffler, and George Jones' key rhythm-man George Riddle, the unheralded musicians whose presence kept a show from falling as flat as a blown tire on the Conowingo Road.

For Leon, as single-minded as he was about making his live recordings, the notion to take pictures came as an afterthought. A friend who worked in Baltimore camera shop sold him a second-hand Zeiss at a discount price of $20 and he became something of an enthusiast like so many shutterbugs of the day, buying books and studying up.

That infatuation drove him to exert the same technical prowess with his photos as he brought to his recording. Raised in a church where graven images were forbidden, he became as devout as any Russian icon-maker. He studied composition and lighting in photography books. He wanted to improve his technique and figure out how to best capture the images he wanted to preserve. He had the sounds from his reel-to-reel tapes, now he wanted the sights to be every bit as sharp and clear and memorable. Each trip to the photo store inspired a mixture of dread and exhilaration as he sweated to see what he'd shot at the country-music parks.

Looking at the photos a half-century later, it is remarkable how much they do tell us. Some of these phantoms died young, fallen prey to the hard-bitten culture in which they were raised. Others faded into obscurity or retirement. But in Leon's photos, they are forever young and aglow, as they alighted from their tour buses and walked the grounds in their spangled, glittering Nudie suits like household gods of a lost Golden Age.

These tender yet never sentimental photographs—one man's souvenirs from summer days along the Mason-Dixon Line—capture these American artists in their prime and in their element, playing country music for country people. Leon would have asked for no greater legacy than that.

*Hank Snow and fans*
*SUNSET PARK*
*1964*

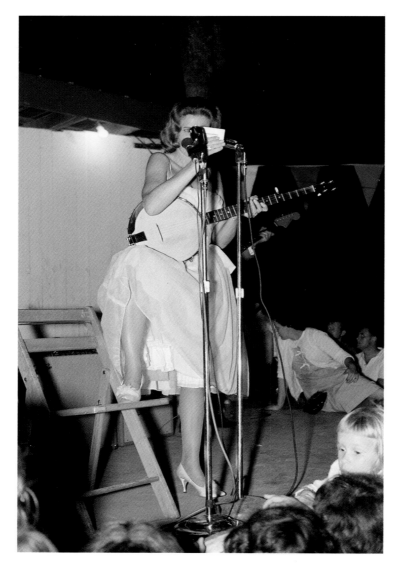

*June Carter*
NEW RIVER RANCH
*1962*

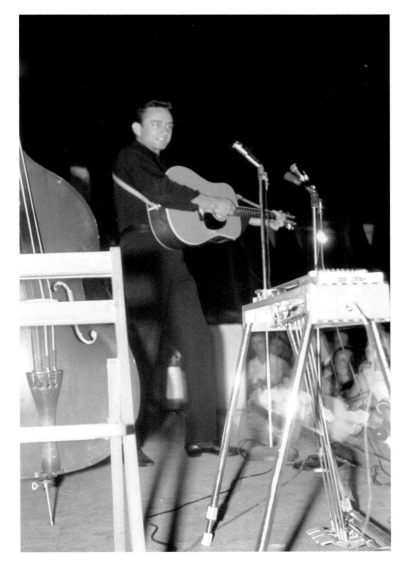

*Johnny Cash*
*NEW RIVER RANCH*
*1962*

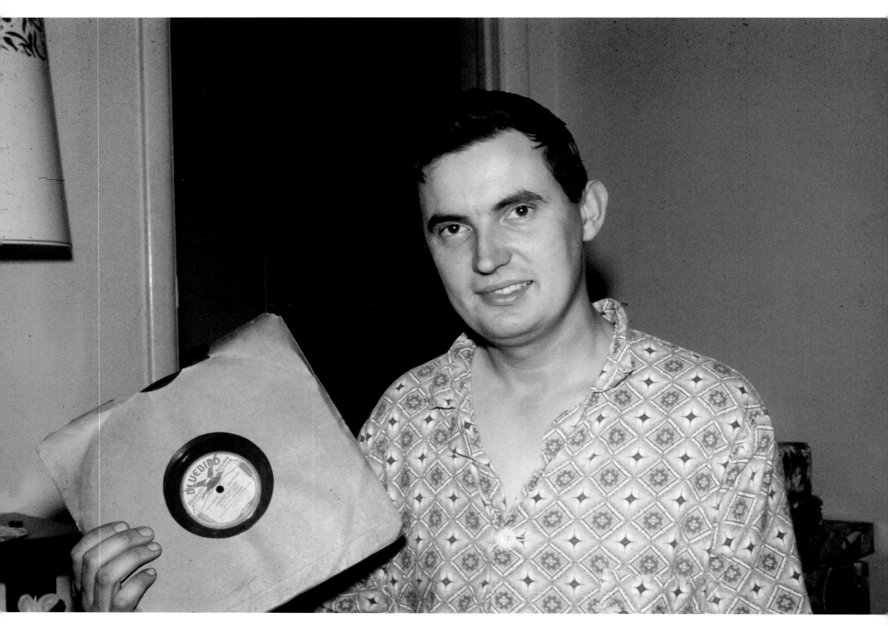

*Leon with one of his finds*

# ❖FIELD HARVEST❖

The raw, from-the-heart sound of traditional country Leon loved most—not only the live music that shook the floorboards at New River Ranch but the old songs he heard on tiny 500-watt stations like WBMD-AM in Baltimore—couldn't be found in record stores or had been out of print for years.

Much as he cherished the tapes he made from the stage or off the radio, he began to covet the 78-rpm records his favorite performers had made before the advent of the slick, studio-produced, assembly-line product of the Nashville Sound. The handful of shellac discs he was able to find at local junk stores were tangible artifacts from country music's glory years and a sort of aural portal to the past, spinning on his phonograph and casting their spell in the solitude of his basement.

One day a man came into the High Fidelity House for repairs on his Ampex recorder. Leon fixed the machine and was astonished as the twin reels revealed in bright, vibrant tones a homemade compilation tape of pristine Pop Stoneman 78s from the '20s and '30s, the zenith of recorded hillbilly music. The man said he had thousands of pre-war records from going door-to-door throughout the South, mostly in mountain regions as yet unmarked on standard road maps. The words jolted Leon as if from a deep sleep, a summons to partake of strange and exciting adventures. He soon found himself on these excursions, worlds away from the sheltered suburban life he had known.

The record-hunting expeditions gave Leon a glimpse of the country life his father had left behind when he brought his family to Baltimore from rural Pennsylvania, a landscape of cows and cornfields. As the trips nosed deeper into Southern Appalachians, home to heroes like the Carters and the Stonemans and the Stanley Brothers, the gridded farmland gave way to weedy pastures with busted fences and collapsed barns. Straight roads turned ever more winding and crooked, and the rolling hills swelled into rugged, steep mountains. Hidden inside the wind-battered frame houses and ramshackle cabins of this remote region were the records bought by the original market audience, and where they remained squirreled away, forgotten and deemed of little value—and yet, true to the ways of mountain folk—never discarded.

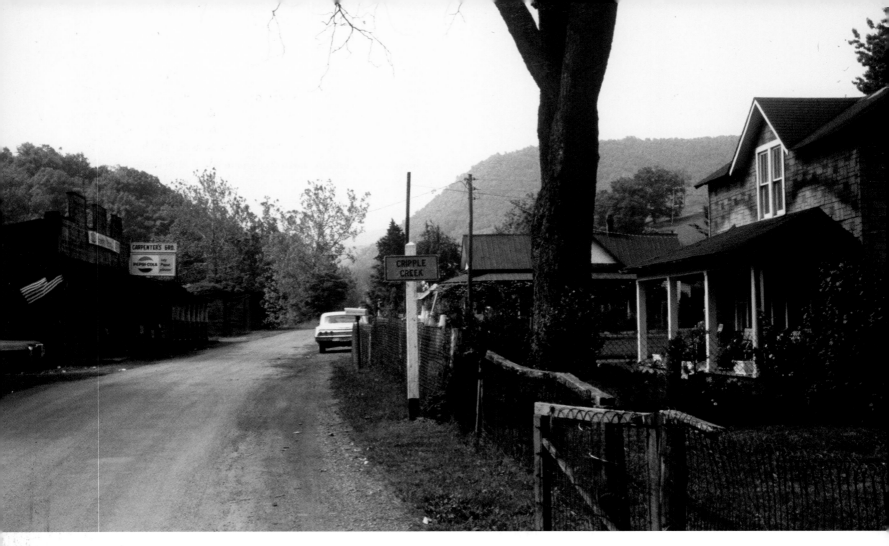

*Cripple Creek, Virginia, late '50s*

I could always tell where the records were by
how the house was kept, whether the roof was
falling down, the chimney's falling down...
the whole thing. You get a sixth sense, and
I was often right. A lot of times the grass
isn't mowed and the house looks like it's
uninhabitable, when in fact it is.

Somebody would come to the front door,
and you're talking way back country
people. These are real country people, and,
incidentally, some of the nicest people I've

ever met. These are good people, these are
people who are of the church, people of
God. And that doesn't seem to be important
anymore, but it is to me, and it was then.

People would answer the door and we were
total strangers. We'd say, "Well, you got any
old records, the kind you used to play in the
Victrola?" And we'd talk about that, and
they'd say, "Well, have you eaten? Well come
on in and eat." Half of them would invite us
in for a meal or at least a snack if it wasn't
meal time.

*And most of them were concerned about
our soul. They would bring out the Bible
and read a verse in the Bible and say, "are
you saved?" They wanted to be sure that
everybody they met was saved, and I thought
that was so neat. My partner didn't, but I
did. I thought it was so kind of them to think
of people in that way. It just blew me away.*

Some of the best finds came in the most desolate places imaginable, like a near-deserted coal camp where a kindly old woman on a porch swing beckoned with a bony finger to survey her stash stored in a backyard shed. Leon sympathized with these poor folk who'd been left behind by progress, and he himself traveled in a style of monkish self-deprivation. His fellow travelers marveled as Leon forsook proper meals at roadside diners, subsisting on a diet of ketchup and hot water he stirred into a makeshift tomato soup. Meanwhile, he often resembled a man on the run, as motel managers banged on his door and reported with stricken faces that his wife was for the umpteenth time placing a person to-person call. When Leon picked up the phone, a haranguing voice resounded over the crackling long-distance line, warning if he didn't come home that instant she would go down into the basement and break every one of his records.

Whether he knew it or not, his collection would far outlast his marriage, and Leon would remain undeterred from his mission. Some of the discoveries were exciting enough to make any hardship seem worth it. In the outback of eastern Tennessee near Chattanooga, Leon hit pay dirt when he found a cache of jukebox stock 78s and 45s from the '30s, '40s and '50s. The records were crammed into a decrepit carousel building that housed not only a merry-go-round but amusements of all sorts stacked to the ceiling—jukeboxes, cast-iron cigarette vending machines, one-armed bandits, roulette tables from casinos, and pinball machines. It was as if all the devices that sprung from the mass urge for kicks in Post-Prohibition America had been gathered in a single mausoleum, where Leon now scampered to retrieve his beloved records, emblems of a lost pastoral paradise uprooted and rendered asunder by the madness of the modern world.

In the wake of these raids deep in the Southern mountains, a Treasure-of-the-Sierra-Madre-like gold fever took hold of many of the record hunters. For Leon, it was a rude awakening to come face-to-face with the lesser angels of human nature, witnessing incidents in which good country people were rooked out of prized 78s by unscrupulous predators.

*A lot of collectors are real low-down sons-
of-a-guns. They're nasty, they're narrow-
minded and they're egotistical. They've just
got to have their rare records no matter what.
Now some collectors, we got some good stuff,
mostly because we were lucky. We didn't rob
or steal or cheat anybody to get 'em. I was
born and raised Christian and for me, God is
first, before any records.*

Even so, Leon eventually amassed a collection of some 250,000 records, a stash so vast that its unwieldy, ever-growing stacks seemed to recreate the mountainous terrain of their origins in his own modest ranch house in north Baltimore. There, visitors were forced to shuffle sideways between towering mounds to get from one room to the other.

Mountain musician Wade Ward recorded as a teen back in the '20s and was still playing the same old-time clawhammer banjo style, known as the Galax Sound from the area where it flourished, when he was rediscovered in the '60s by young enthusiasts like Leon, who visited Ward at his house in southwest Virginia.

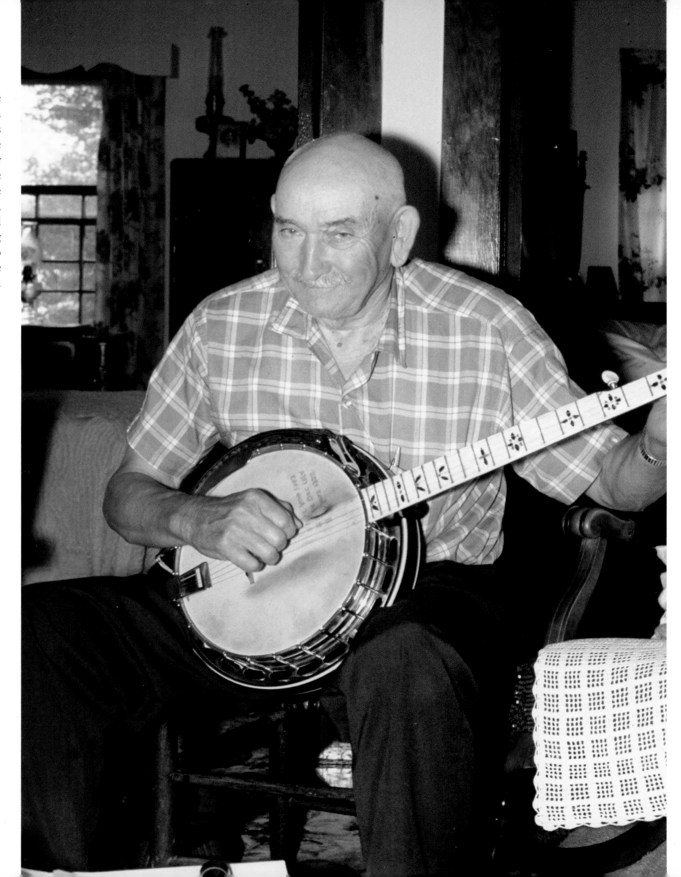

*A record owner's home, Southwest Virginia*

The records, most of them, anyway, were eventually bought by a collector when Leon was in need of some cash, and it took several U-Hauls to remove the stash.

So the records were for Leon mostly a means to an end, that end being to get ever closer to the music that gave him so much peace and joy. Despite his hoarding and collecting, he was never a mere materialist, and he knew more than most that all things were as dust.

The photos Leon took on his road trips show that even in the heat of the hunt, he kept his eyes and heart open to the journey he was on. He was a dutiful chronicler of the dusty back roads and dark hollows and rocky ridges from whence the music he loved had sprung as naturally as the mountain laurel and the fox grape. Like a pilgrim back from the Holy Land, he had found the source of his inspiration.

*Virginia countryside*
*1950s*

*Record hunt home*
*VIRGINIA, 1950s*

## A.P. Carter's House

*A friend and I were on one of our many
record hunts back in the early sixties and we
found the Carter House. A lot of people tried
and never found the Carter House. We found
it by listening to the words in some of their
recordings and asking all of the restaurants
nearby. It was right outside of Gate City,
Virginia, and it was the original A.P. Carter
house that (his ex-wife) Sarah was still
living in.*

*She invited us in her living room and we
talked for half an hour. We played A.P.
Carter's guitar, on which they made about
half their recordings, and they'd made like
400 recordings back then. They were big in
the country music field, one of the biggest
sellers at that time along with Jimmy
Rogers. And of course she told a lot of stories
about the early days of recording.*

*Sara Carter*

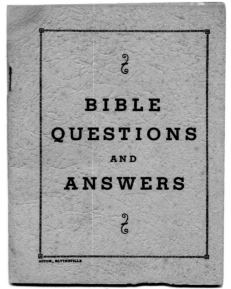

BIBLE
QUESTIONS
AND
ANSWERS

We were there for the better
part of an hour.

And the time it was about
over, I think she saw we
were sincere in our love for
country music, and needless
to say the Carter Family—
we had great interest in
them—and I don't know
why, but she decided to give
me some things. She gave
me a record contract signed
by A.P. Carter and Ralph
Peer, and this copy of a book
A.P. Carter had written
called "Bible Questions and
Answers." they were very
religious people.

*A.P. Carter House*
*MACES SPRINGS, VA*
*1960s*

❖**27**❖

WITNESSETH:

(1) The WRITER hereby sells, assigns, transfers, and delivers to the PUBLISHER, its successors and assigns, all of his rights, title, and interest in and to a certain heretofore unpublished lyric, as annexed hereto and made a part hereof, written by the WRITER, now entitled

## LIVE ON DOWN THE LINE

as well as the entire exclusive right to publicly perform, together with the right to secure copyrights and renewals therein throughout the world, as proprietor in its own name, or otherwise, and to have and to hold the said work, copyrights and renewals thereof, and all rights of whatsoever nature thereunder existing.

(2) The WRITER hereby warrants that the said lyric is his sole, exclusive and original work, that he has full right and power to make the within agreement, and that there exists no adverse claim to or in the said work which is free from all liens and encumbrances whatsoever.

(3) In consideration of this agreement, the PUBLISHER agrees to pay the WRITER, jointly, when the lyrics are used, only the following royalties:

(a) _____ 3 ¢ per copy in respect of regular piano copies and/or orchestrations containing said lyrics, sold in United States for which the PUBLISHER received payment.

(b) _____ 50 % of the net amount received by the PUBLISHER in respect of regular piano copies and/or orchestrations containing said lyrics, sold and paid for in any foreign country.

(c) _____ 50 % of the net amount received by the PUBLISHER in respect of any licenses issued, authorizing the manufacture of parts of instruments serving to mechanically reproduce said lyrics, electrical transcriptions, or to use said lyrics in synchronization with sound motion pictures.

(d) _____ 50 % of the net amount of performing fees received by the PUBLISHER in the United States, only provided said fees include both WRITER and PUBLISHER shares and are payable on a fixed and determinable basis.

(4) The PUBLISHER agrees to render the WRITER on or about February 15th and August 15th of each year, so long as it continues publishing or licensing said lyric, covering the six months ending December 31st, and June 30th of each year respectively, royalty statements accompanied by remittances of the amount due.

(5) The PUBLISHER shall have the right at all times to alter, change, edit or translate the lyrics or any part thereof, in any way it may deem necessary. The PUBLISHER shall not be obligated to print and use said lyrics with any particular music, and thereafter having printed, sold and used said lyrics with a certain particular melody or composition, anything to the contrary notwithstanding, the PUBLISHER shall at all times have the right, in its discretion, to print, sell and use the lyrics of others with the said certain particular melody or composition, in which event the PUBLISHER agrees to pay to the WRITER the sum of Twenty-five ($25.00) Dollars, within thirty (30) days after written demand forwarded by registered mail in full settlement thereof. And the PUBLISHER shall be obligated to pay the hereinbefore provided royalties to the WRITER only in the event the lyrics of the WRITER herein assigned are actually printed, sold, and used.

(6) The WRITER hereby agrees to indemnify and save harmless the PUBLISHER against any loss, expense or damage by reason of any adverse claims made by others with respect to the work, and agrees that all expenses incurred in defense of any such claims, including counse fees, as well as any other sums paid by the PUBLISHER, pursuant to judgment, arbitration or any settlement or adjustment which may be made in the discretion of the PUBLISHER, or otherwise, shall at all times be borne by the WRITER, and may be deducted by the PUBLISHER from any money accruing to the WRITER under this agreement, or otherwise.

(7) The WRITER agrees that he will not assign this agreement nor any sums that may become due hereunder, without the written consent of the PUBLISHER first endorsed hereon.

(8) Except as otherwise herein provided, this agreement is binding upon the parties hereto and their respective successors in interest.

(9) All sums hereunder payable jointly to the WRITER shall be divided and paid in the following manner:

100 % to A.P. CARTER _____ of _____

_____ % to _____ of _____

WITNESS _____ X _____*A. P. Carter*_____

WRITER     A.P. CARTER

WITNESS _____

Rear view of the former
Carter's grocery store,
designed and built by A.P.
himself, in the foothills
of Clinch Mountain.

*MACES SPRINGS, VA*
*1960s*

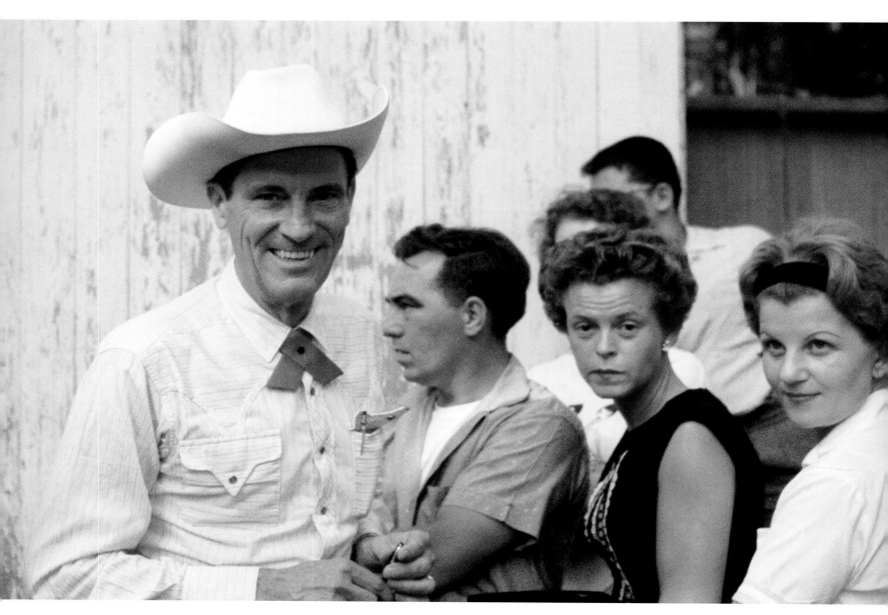

*Ernest Tubb*
*NEW RIVER RANCH*
*1962*

# ❈SUNRISE❈

NEW RIVER RANCH, RISING SUN, MARYLAND

When Leon first heard ads on the radio for country-music shows at New River Ranch in Rising Sun, the very name sounded magical, conjuring images of crystal-clear rushing water, the first rays of dawn, and the jingle of Tex Ritter's spurs.

Here each and every Sunday from spring to fall, country stars came to perform all-day, outdoor shows for just $1 per carload. It was outside the rural hamlet of Rising Sun, Maryland, less than an hour's drive from Leon's home in suburban Baltimore. It was as if the Good Lord had ordained it: *Let there be live country music near Leon's dwelling-place, featuring his favorite performers, at a price even Leon can afford.*

The river was in fact a copperhead-choked tributary of the Susquehanna called Octoraro Creek, which wound its way through a dense hollow off U.S 1 highway, and the ranch was nothing more than a makeshift wooden stage under the trees, rows of sawmill planks for seats, and two outhouses shared by performers and fans alike. Leon was elated with the primitive, backwoods setting.

The park was operated by Ola Belle Reed and her brother Alex Campbell, local hillbilly musicians who originally hailed from the mountains of North Carolina. Few could pronounce the creek's Indian name, so the duo christened their down-home country-music show park "New River Ranch." It was at its peak when Leon first arrived in the late '50s. After two years as a spectator, Leon one day decided to start recording the live shows. "I got to thinking, 'I've got a tape recorder at home and I know how to tape...'" Nobody asked him to, and he told no one of his fateful decision.

The first show Leon recorded was a Flatt & Scruggs performance in 1960. He packed his reel-to-reel Ampex 960 and his Omni-directional ElectroVoice 654 microphone into the trunk of his '49 Plymouth, and, after attending Sunday church service, he headed

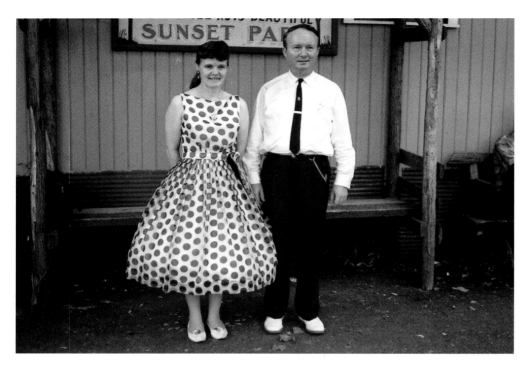

*Ola Belle Reed and Alex Campbell*

clap down on his shoulders, along with a sharp reprimand. "I felt ashamed to put that mic up there. I thought I'd get thrown out for sure, but nobody said anything. And so I didn't say anything either, just did my thing as quietly as I could so as not to bother anybody. I was a shy son-of-a-gun and I wouldn't hardly talk to people at all."

Later, Leon received permission from the park owners as well as the performers to make his recordings. As it turned out, the roofless stage provided the ideal perch for Leon to capture the shows on his reel-to-reel recorder. For some reason, the sound was better at New River Ranch than at other parks. The acoustics were superb, and Leon often recorded the cornball jokes and on-stage asides and repartee that made the shows such intimate affairs.

for Rising Sun, his heart racing as he drove across the harrowing two-lane blacktop atop the Conowingo Dam, a crossing over the wide and mighty Susquehanna that always terrified him. The site of the park was so remote, and the entry sign so small, that Leon often missed the turn. Half a mile down a rocky dirt road, deep in the hollow, in a clearing carved out of the woods, gathered crowds of up to several thousand fans, the entire spectacle unseen and unheard by the steady traffic of vacation-goers on the Maine to Florida route of the U.S. 1 Highway. It was a subculture bypassed altogether by mainstream Americans during the Eisenhower Era.

At the park, the midday sun beat down as Leon set up his gear, gingerly placing his prized Electrvoic mic that cost $100 (more than a week's salary at the Hi-Fidelity House) next to the stand of house microphones and then snaking back the cable through the crowd to his Ampex recorder. He kept waiting for a heavy hand to

Not long after the Flatt & Scruggs show, Leon began bringing his Zeiss Ikon camera to the New River as well. As

```
        COMING ATTRACTIONS!!        NEW RIVER RANCH!!!
        ─────────────────────────────────────────────
        AUG. 19th...  OSBORNE BROTHERS!!      CLYDE MOODY!!
        AUG. 26th...  LONZO & OSCAR!!    JIMMY MARTIN & THE
                                              SUNNY MT. BOYS!!
        SEPT. 2nd...  WILBURN BROTHERS!!!
        SEPt. 3rd...  BIG LABOR DAY SHOW!
        STARRING:
              JOHNNY CASH!!         GEORGE JONES!!
           MOTHER MAYBELIE!!       CARTER SISTERS!-
              GORDON TERRY!!    AND OTHERS!!
        ....##.....DON'T MISS THIS ONE!....##.......
```

# NEW RIVER RANCH

*Maryland's Little Nashville*

## HOME OF COUNTRY MUSIC

2 Miles North of Conowingo Dam, U. S. Route 1, Rising Sun, Md.

## Labor Day, Sept. 2, 1963

### COUNTRY MUSIC SPECTACULAR

 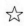

## In Person

# George Jones
## and The Jones Boys

★ **Melba Montgomery and Shot Jackson**
(We Must Have Been Out Of Our Minds)

★ Jeff Simmons "Mr. Cash"   ★ Carter Kids and others

*Your Friends Will Be There, How About You?*

BRING PICNIC LUNCH AND STAY ALL DAY

ADMISSION IN ADVANCE $1.00 — AT GATE $1.50   (CHILDREN UNDER 12 FREE)

WRITE TO NEW RIVER RANCH, BOX 230, RISING SUN, MD. FOR TICKETS.

## PLEASE POST - THANKS

the recorder ran, with the levels meticulously set and plenty of tape on the reels, Leon wandered the grounds, snapping photos of the stars mingling or signing autographs for fans.

That country setting often created havoc onstage, where pests and varmints often took refuge at night only to get a rude awakening at showtime. A swarm of yellow jackets attacked the Stanley Brothers during a performance, and Leon captured on tape the moment when Brother Ralph wisecracked into the mic, only half in jest, "Get the DDT, Let's burn 'em out!" A Reno and Smileys show was marred by the conspicuous presence of a family of skunks that sprayed the crowd with all their defenses.

For the most part, though, the natural surroundings served to enhance not only the music but the backwoods ambience at New River Ranch, which resembled a family reunion and a brush-arbor revival, especially when it came to the hymn-time segment with which performers always closed their shows.

Here, lost in the pines and over yonder past the briars, were the colorful country stars at home back in the sticks where they were raised, whether it was Ira and Charlie Louvin taking a cigarette break down by the creek, or a solitary Carter Stanley lost in thought at a picnic table, gathering strength after an all-night drive to the park. And no matter how famous or how tired, they were always polite and friendly and willing to smile and pose for the kind, shy shutterbug who never even told them his name.

MARYLANDS ONLY COUNTRY MUSIC RANCH
NEW RIVER RANCH          RISING SUN, MD.
SUNDAY JUNE 14th, 1959.
- PATSY CLINE -
DIRECT FROM
Jimmey Dean
CBS-TV SHOW
Also
- Hank Rector & Band -
PLUS
FIVE GUEST COUNTRY MUSIC BANDS
PARK OPENS AT 10: A.M.   SHOWS START AT 1: P.M.
COME EARLY AND STAY LATE.        FRANK & VIA.

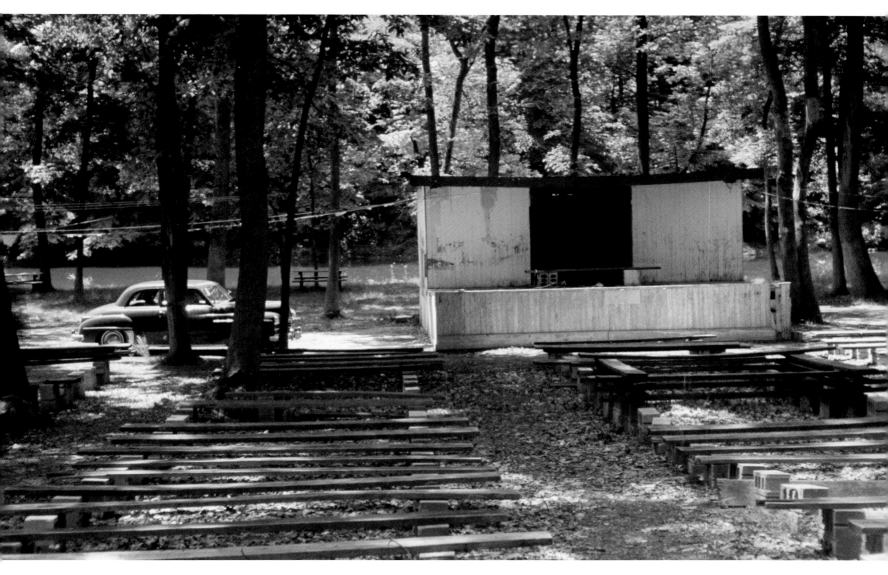

# Stage at New River Ranch,

*RISING SUN, MARYLAND, 1958*

On the banks of the Octoraro Creek, hidden from nearby US 1 Highway by a tangle of woods, New River Ranch was about primitive as could be. The stage, a pile of second-hand lumber held together with 10-penny nails, was a fitting platform for the rough-hewn, backwoods music presented here. "When people would stomp on the stage, it would almost collapse. The whole thing was made with about a hundred dollars' worth of wood, and it wasn't particularly well constructed. The back was just rotting away like crazy but somehow it never fell down." A steep hill sloping from the water's edge provided a natural amphitheater for the overflow crowds, often numbering several thousand strong, who covered the grass and even climbed the overhanging trees for a view of the shows. Once the throng left, it had the look of a site abandoned for years, not hours. Leon was often the last to leave, and he would linger alone in the woods, before finally packing the spoils of the day into his '49 Plymouth for the drive home.

## Silver Fiddler's Convention

*NEW RIVER RANCH, 1958*

*So the park got electricity tapping off of a line at the road and running temporary wires back to the park. Now whether that was legal or not, I don't know, and I could care less, but it didn't look legal to me. Well, the electricity wasn't very good and if you turned too many things on, it would dim. And this is unbelievable, but it's true. And on stage they had two light bulbs, and that was all they had at night. So after dark they had two lightbulbs and guess what? They were behind the stars! So it really didn't do much, and there was enough to run my Ampex but it wasn't a whole lot more.*

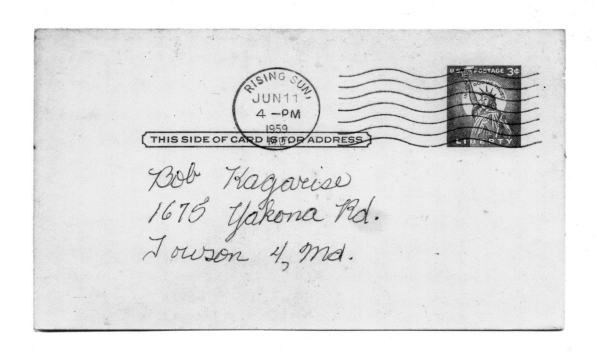

THIS SIDE OF CARD IS FOR ADDRESS

RISING SUN
JUN 11
4 —PM
1959

U.S. POSTAGE 3¢
LIBERTY

Bob Kagarise
1675 Yakona Rd.
Towson 4, Md.

SUNDAY AUGUST 2nd.

NEW RIVER RANCH          RISING SUN, MD.
MARYLANDS ONLY COUNTRY MUSIC RANCH

## BILL MONROE AND THE BLUE GRASS CHAMPS

PLUS

**HANK RECTOR, THE RAMBLING RANGERS, AND OTHERS.**

Park opens at 10 A.M. Shows start at 1 P.M.

LOOK          LOOK          LOOK

SATURDAY AUGUST 8th

## SILVER FIDDLERS CONVENTION

ALL PRIZES IN SILVER DOLLARS
$50 SILVER DOLLARS GRAND PRIZE

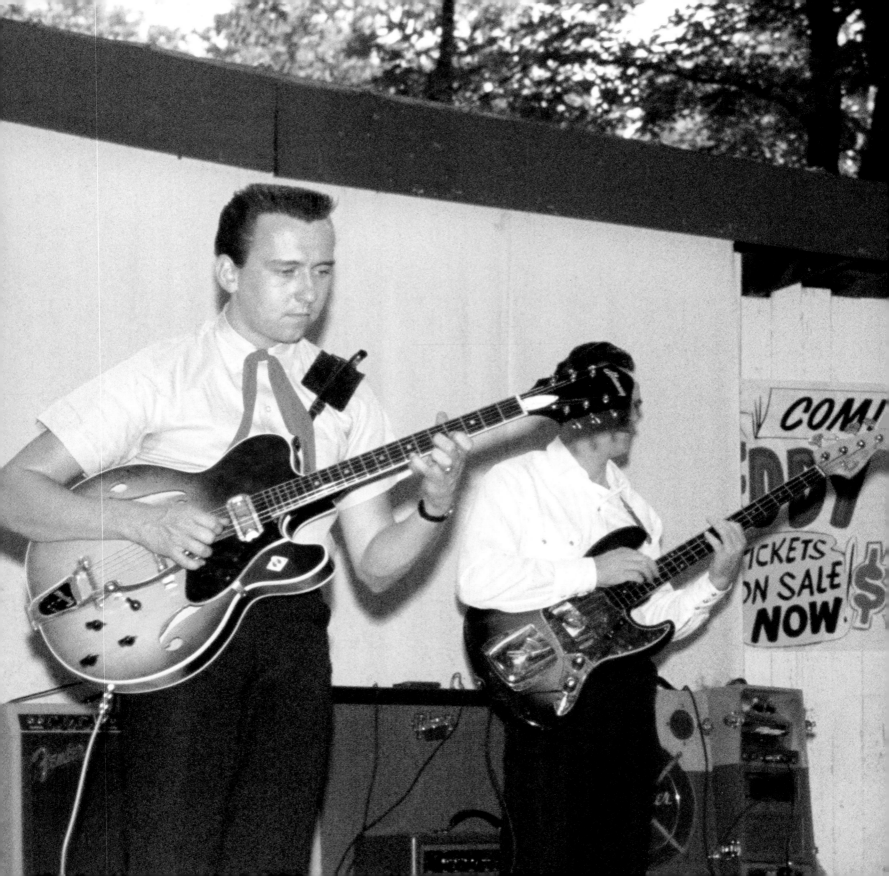

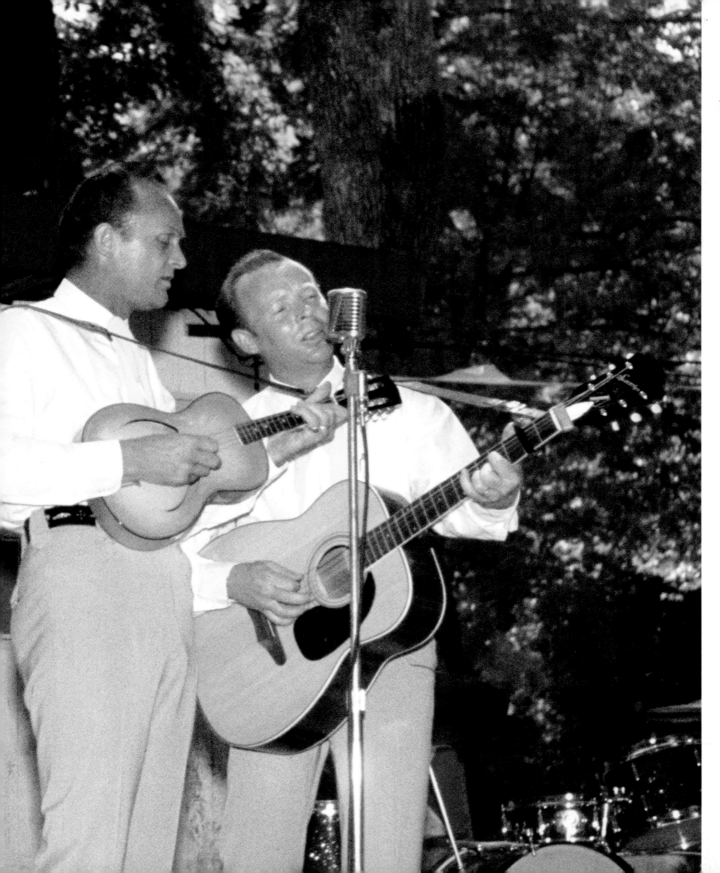

*The Louvin Brothers*
*NEW RIVER RANCH*
*1962*

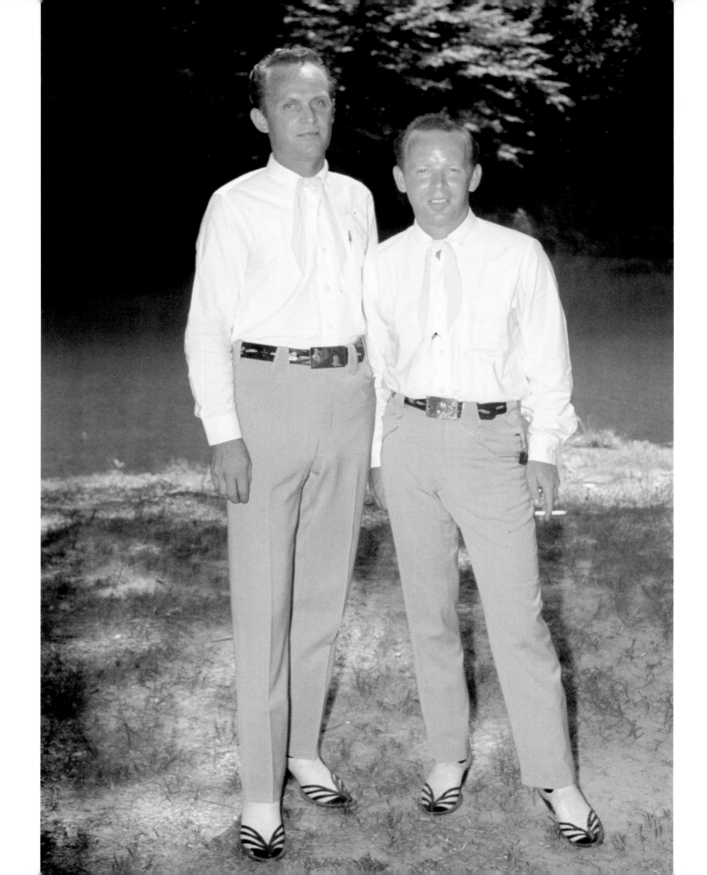

# Ira and Charlie Louvin

*NEW RIVER RANCH, 1962*

Ira and Charlie Louvin epitomized the ecstatic expression of the most hallowed country harmony singing, the brother duet, the ultimate in male bonding forged in the church and the honky tonks. Ira was the older Louvin and the musical genius of the two. He sang like an angel but he could be as mean as a striped snake, almost as famous for his drunken, mandolin-smashing tantrums as for his hair-raising tenor. That's Ira on the left. He carries five bullets in his back, courtesy of an ex-wife who tried to kill him after he attacked her with a telephone cord. The Louvins were among the least approachable performers on the country-music park circuit, and Leon managed this revealing portrait when he caught them taking a cigarette break far from the stage down by the Octoraro Creek at New River Ranch. "I saw the Louvins play twice at New River and I liked them very much, but they weren't as friendly as some of the country stars." Judging from their uneasy stares, they don't appear pleased with the camera, much less with each other, and soon after, the brothers broke up the act. Charlie said he could no longer endure his brother's abuse. In 1965, Ira was studying to be a preacher when he was killed in a head-on collision with a drunk driver.

# Red Allen & Frank Wakefield

*NEW RIVER RANCH, 1961*

Veterans of the rough-and-tough hillbilly bars in Dayton, Ohio where they met in the '50s, Red Allen, left, and Frank Wakefield were vital carriers of bluegrass fever to eastern cities like Washington DC. The eccentric Wakefield was a mandolin wunderkind from Emory Gap, TN., who had a fondness for Bach as well as Bill Monroe, and he would sneak in classical allusions in his mercurial solos that tangled the feet of mountain-dance cloggers and inspired an entire school of mandolin players.

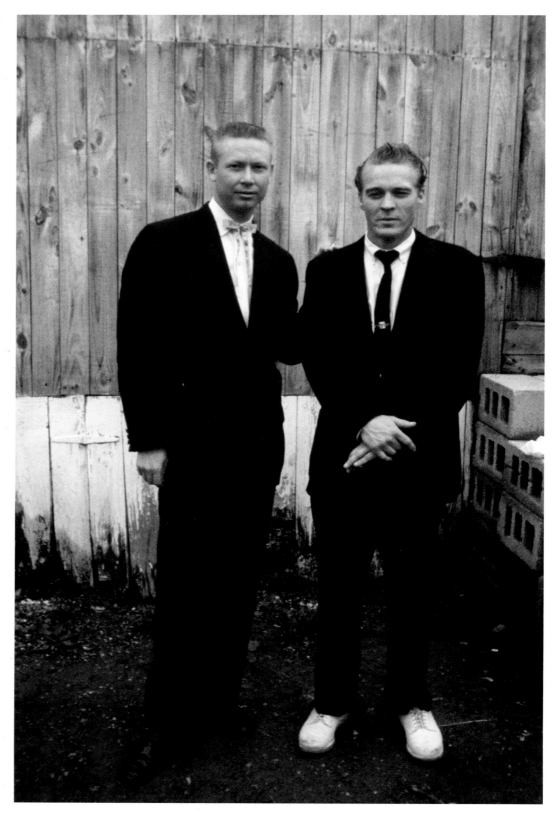

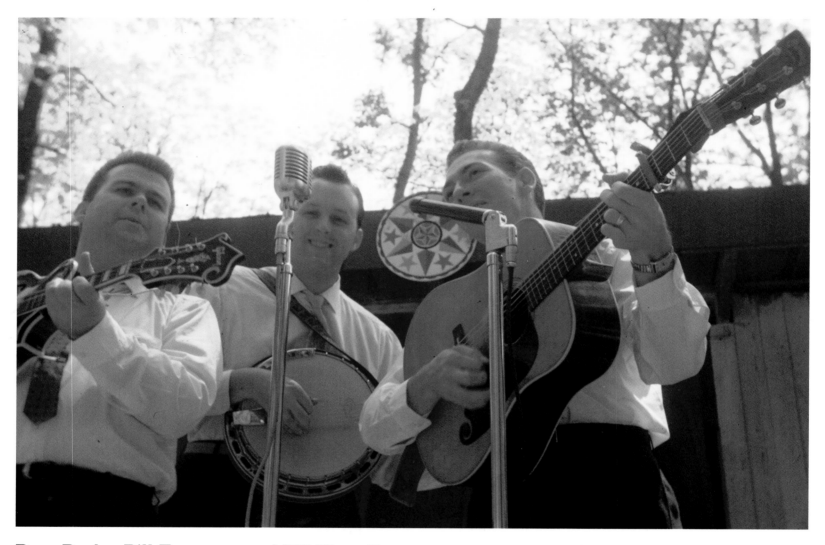

## Buzz Buzby, Bill Emerson, and Bill Harrell

*NEW RIVER RANCH, 1961*

In the '50s and early '60s, Washington D.C. was the country-music capital of the East, busting loose with homesick hillbilly migrants packing chicken-wire beer joints like the Pine Tavern, The Ozarks and the Famous, next to the downtown Trailways bus station. Buzz Busby played them all, mostly for tips and not much else, but he nonetheless earned legendary status as a hard-living purveyor of hardcore bluegrass that cut close to the bone, teeming with manic mandolin runs and hair-raising, high-lonesome harmonies.

Like Scott Stoneman, who often backed him on fiddle and went carousing with him until daybreak, Busby had a wild streak a mile wide. A near-fatal car accident in 1957 after a show derailed a promising career, yet he still managed to make some of the era's greatest bluegrass records, works of eerie beauty such as "Lonesome Wind," "Cold and Windy Night," and "Lost."

*Bill Monroe*
*NEW RIVER RANCH*
*1961*

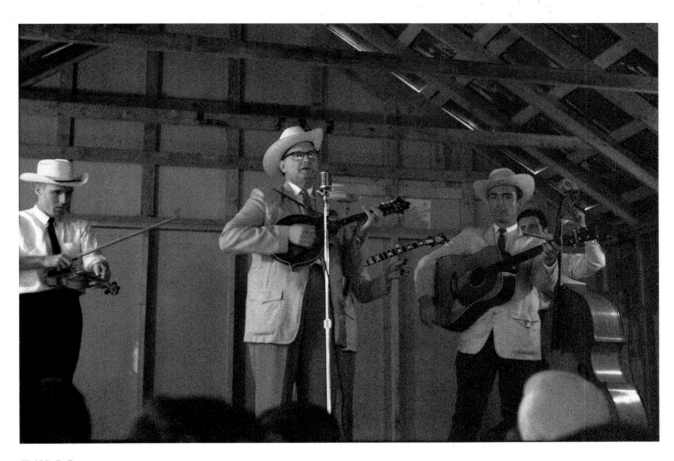

## Bill Monroe

*NEW RIVER RANCH, 1963*

*New River Ranch did not have a roof, so when it rained, it pretty much was a washout. But they did have a small building there that held, believe it or not, about 40 people. It was way too small. But some of the die-hards stayed, and sometimes the performance went on and sometimes it didn't. Bill Monroe played there. He was true to his fans, and he did stay and play in that little building. And at that time he was probably on top; Bill Monroe was huge. He was known all over the world, and for anybody who knows country music, he was like one below God.*

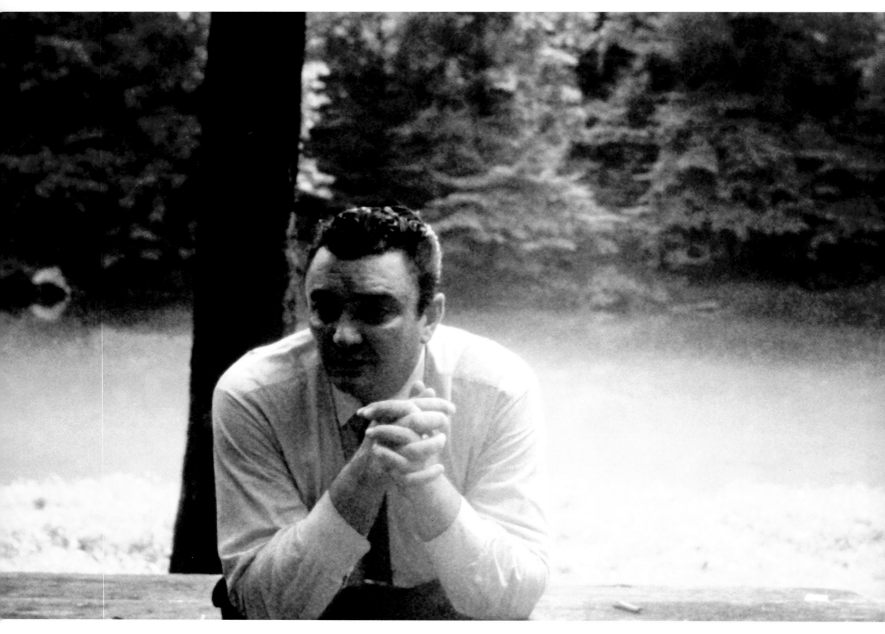

*Ralph Stanley*
*NEW RIVER RANCH*
*1961*

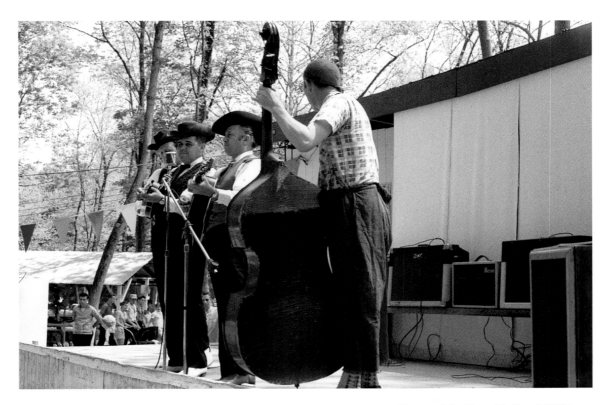

*Jimmy Martin with Paul Williams*
*NEW RIVER RANCH*
*1961*

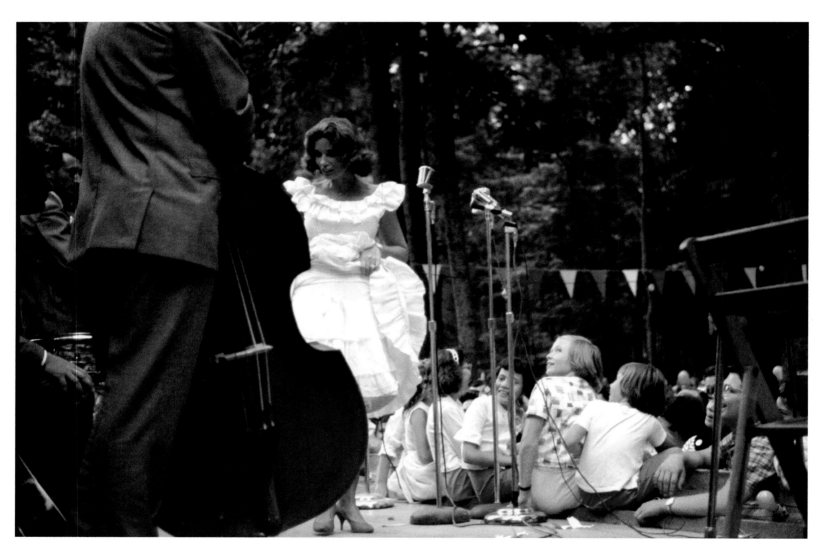

*June Carter, with The Johnny Cash Show*
*NEW RIVER RANCH,*
*1962*

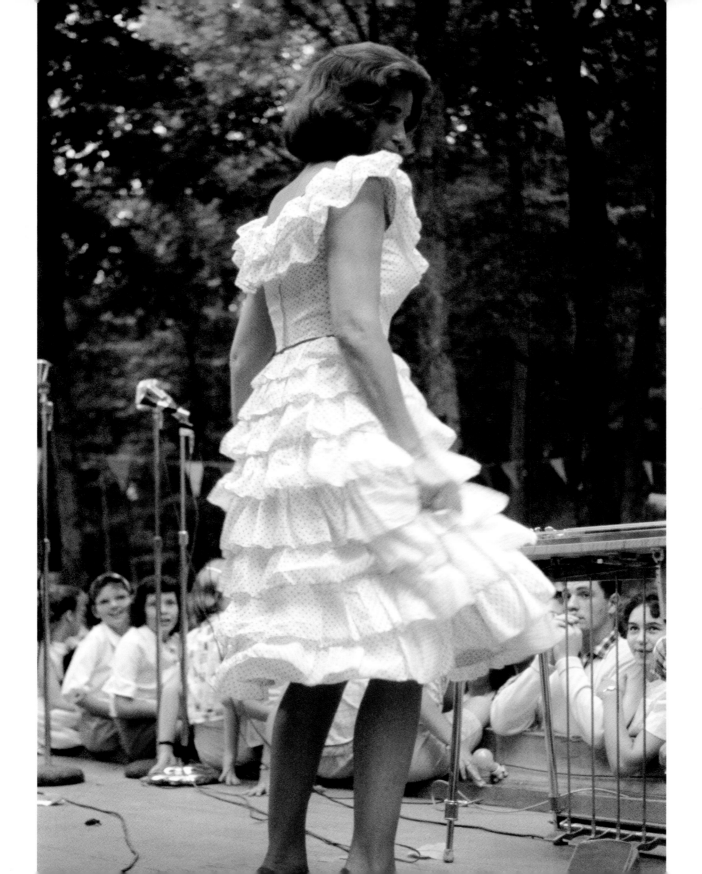

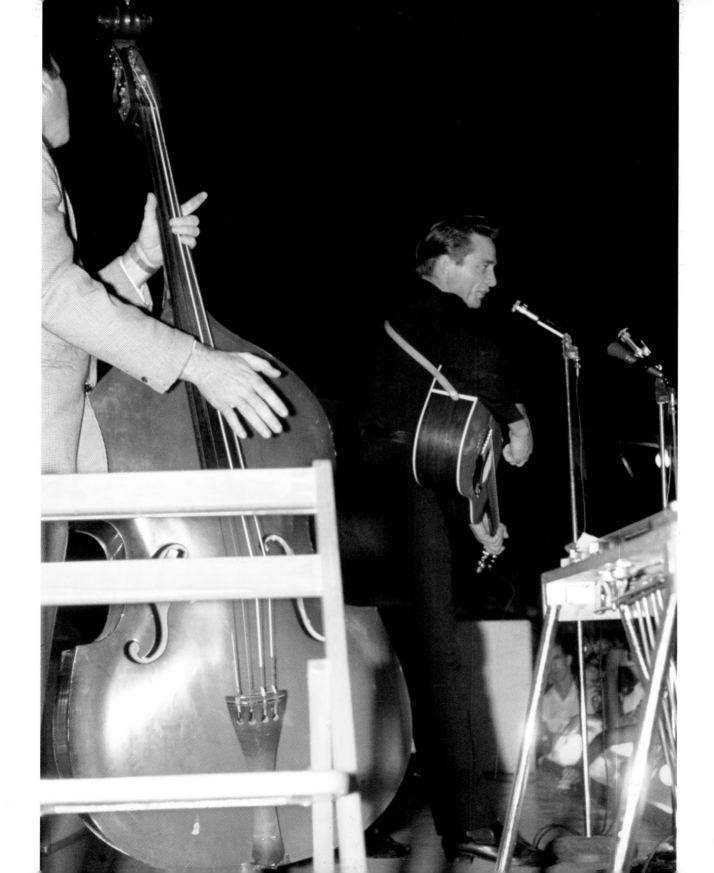

## June Carter and Johnny Cash with fans

*NEW RIVER RANCH, 1962*

In 1961 the Carter Sisters joined the Johnny Cash road show, and it was during this time when June and Johnny became smitten with each other, a chemistry that was for years held in check by Cash's addiction to pills and booze. They would eventually marry in 1968.

*PREVIOUS PAGES:*
*June Carter and Johnny Cash*
*NEW RIVER RANCH*
*1962*

George Jones
with George Riddle
*NEW RIVER RANCH*
*1962*

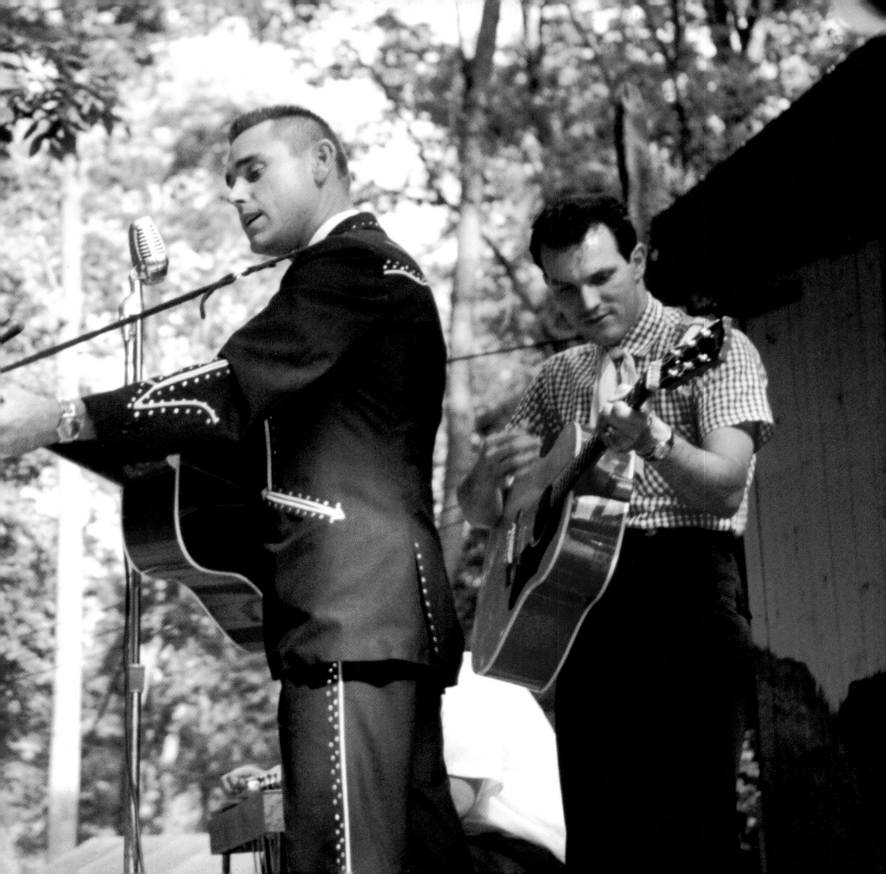

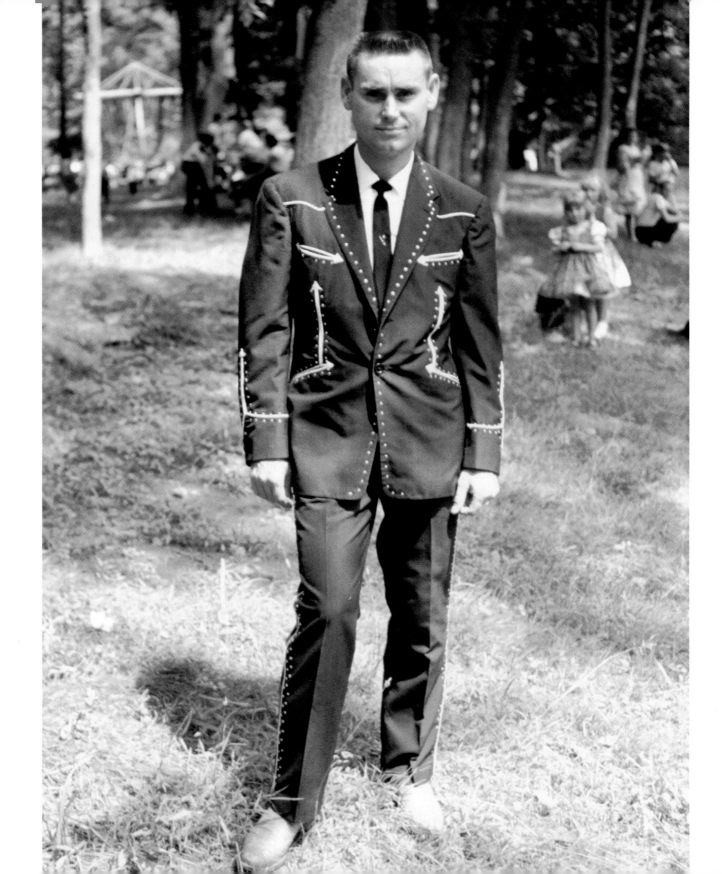

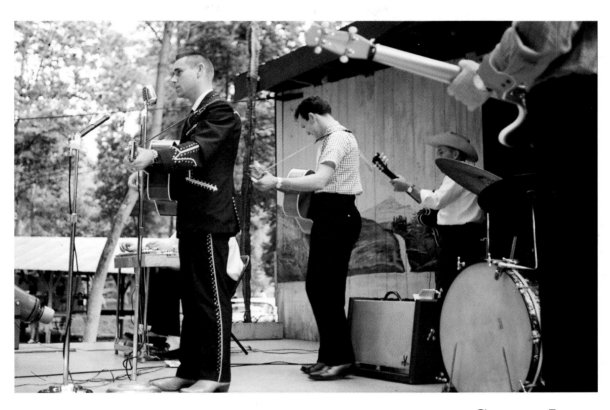

## George Jones
### *NEW RIVER RANCH, 1962*

For years George Jones was country music's greatest singer and biggest drunk. Blessed with a voice that could plumb the deepest recesses of the human soul, he was cursed to live out the words to his classic honky-tonk songs of misery and heartache. He earned the nickname "No Show" Jones, and when he did manage to make an appearance on stage as scheduled, it was often only to put his private demons on full public display. For a weekend date at New River Ranch, Jones showed up Saturday with a pick-up band from Baltimore that couldn't play the songs to his liking. He was raging drunk and madder than hell and he promptly fired the band onstage. "He's using all the big bad words and there are kids in the audience, families," said Leon. Jones demanded a phone so he could call his manager, but at New River Ranch there were no such modern conveniences. "This is way back in the woods," said Leon. "So then he had to walk a half-mile down the road to a store to use the telephone, cussing the whole way." The next day, Jones was back—same suit, same band, same stage—but a new man, sober, contrite and quietly affable enough to stand for a portrait.

*Carl Smith*
*NEW RIVER RANCH*
*1961*

## Ray Davis, MC

*SUNSET PARK, 1961*

Ray Davis, Baltimore's biggest booster for
hillbilly music, broadcast his radio show on
WBMD from a second-floor, walk-up studio
at Johnny's Used Car Lot on Harford Road
for decades from 1951 on. He was one of
the first disc jockeys on the East Coast to
play the records of Bill Monroe, Reno &
Smiley and the Stanley Brothers for the rural
migrants who'd moved north for work after
World War II. Davis' predilection for raw,
hardcore bluegrass done the old way—only a
single microphone on-stage or in the studio,
when band members would duck in and out
of the mike and never miss a lick—formed
the taste of an entire generation of locals.

A smooth operator with a country-fried
baritone courtesy of his upbringing in the
remote Eastern Shore town of Wango, Davis
could work a crowd like nobody's business,
and for many years he was the MC at
Sunset Park.

## Ray Price

*NEW RIVER RANCH, 1960*

The ultimate honky-tonker who recorded Night Life, a concept album about tomcatting around 'til dawn, was most at home playing dark, smoky dance halls, but he could still hold his own in the white-hot glare of the July sun at the country-music parks.

*Ray Price with fan*
*NEW RIVER RANCH*
*1960*

# The Osborne Brothers

*NEW RIVER RANCH, 1961*

Though they dabbled with drums and
piano and other touches that rankled
some purists, Sonny and Bobby Osborne
kept their high harmony singing pure and
unsullied, taking bluegrass to the country
charts at a time when the polished
Nashville Sound reigned supreme.

*Hank Locklin*
*NEW RIVER RANCH*
*1966*

*Jim Reeves*
*GWYNN OAK PARK, MD*
*1960*

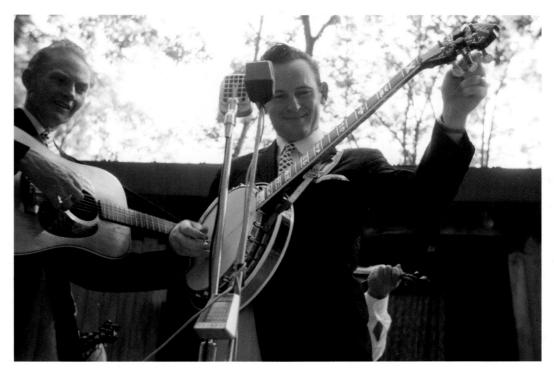

## Reno & Smiley

*NEW RIVER RANCH, 1961*

The music of Don Reno and Red Smiley carried a strong emotional force, and was always under-appreciated. Just a notch below the holy triumvirate of first-generation bluegrass, Bill Monroe, Flatt & Scruggs, the Stanley Brothers, they were present at the creation. Their early hit from 1952, "I'm Using My Bible for a Road Map," was penned by Reno after a car wreck laid him up in a hospital and got him thinking about mortality.

*Don Reno*
*NEW RIVER RANCH*
*1960*

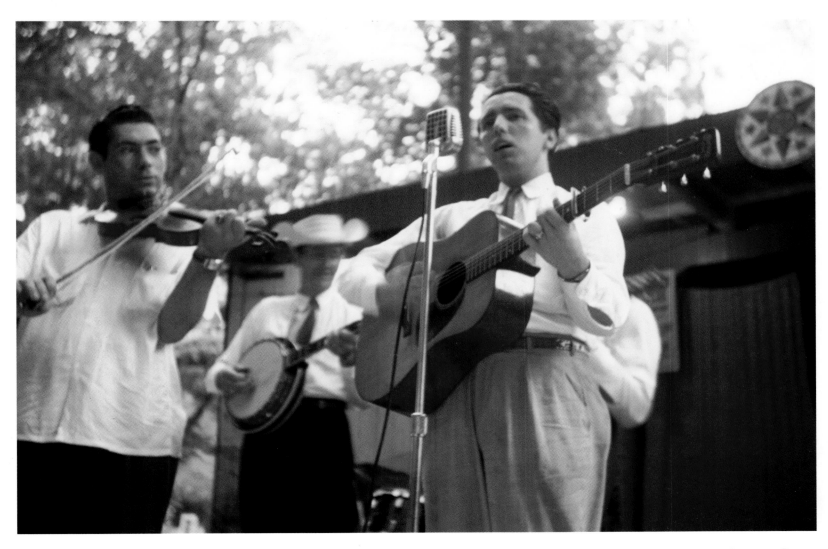

*Jack Cooke with Bill Monroe's Bluegrass Boys*
*NEW RIVER RANCH*
*1961*

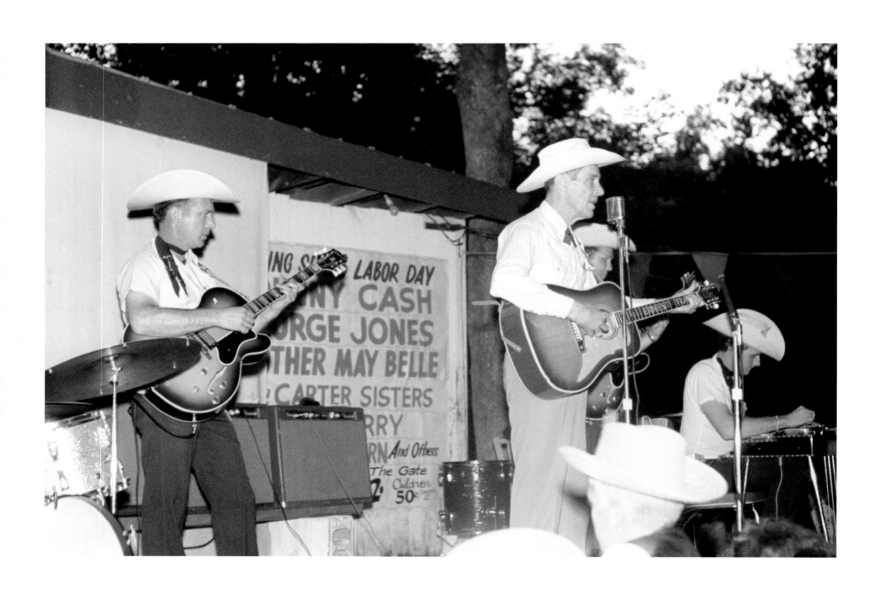

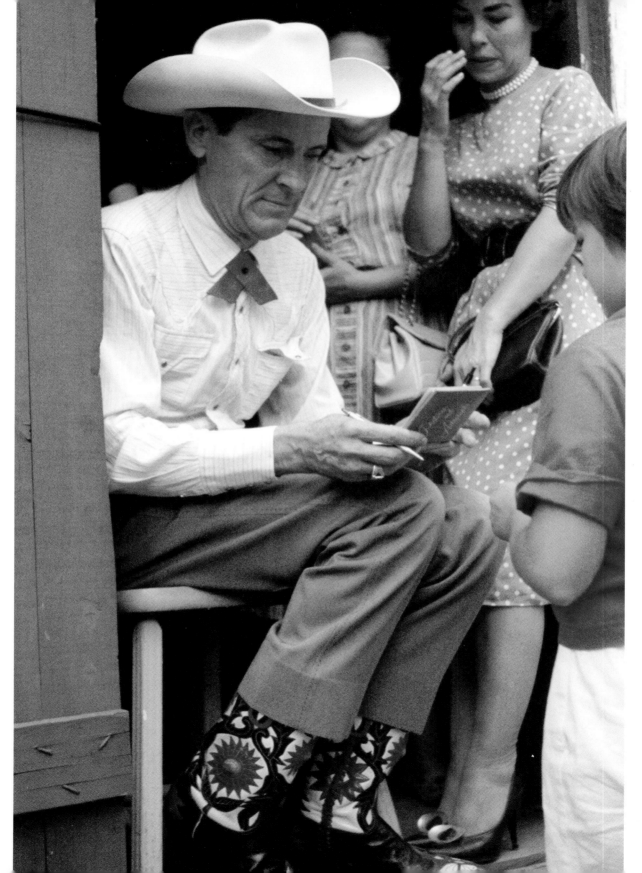

*Ernest Tubb*
NEW RIVER RANCH
*1962*

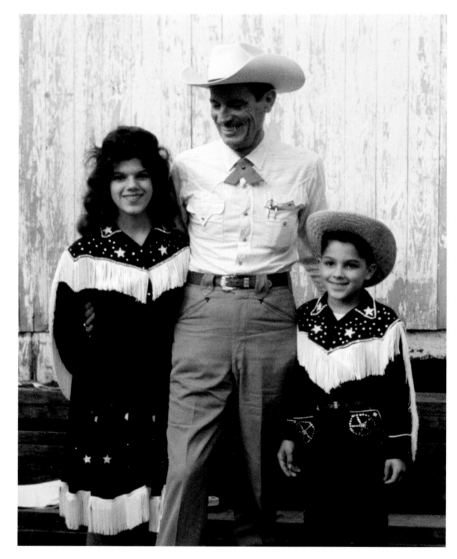

## Ernest Tubb with Carter Kids

*NEW RIVER RANCH, 1962*

Shown here with the Carter Kids, a rockabilly act from Virginia, Ernest Tubb nurtured the careers of many country performers from Hank Williams and Patsy Cline on down. E.T. did right by his family as well, getting his eldest son Justin (opposite page) onto the Opry stage at nine, and guiding his progress as a singer and songwriter of such hits as "Lonesome 7-7203."

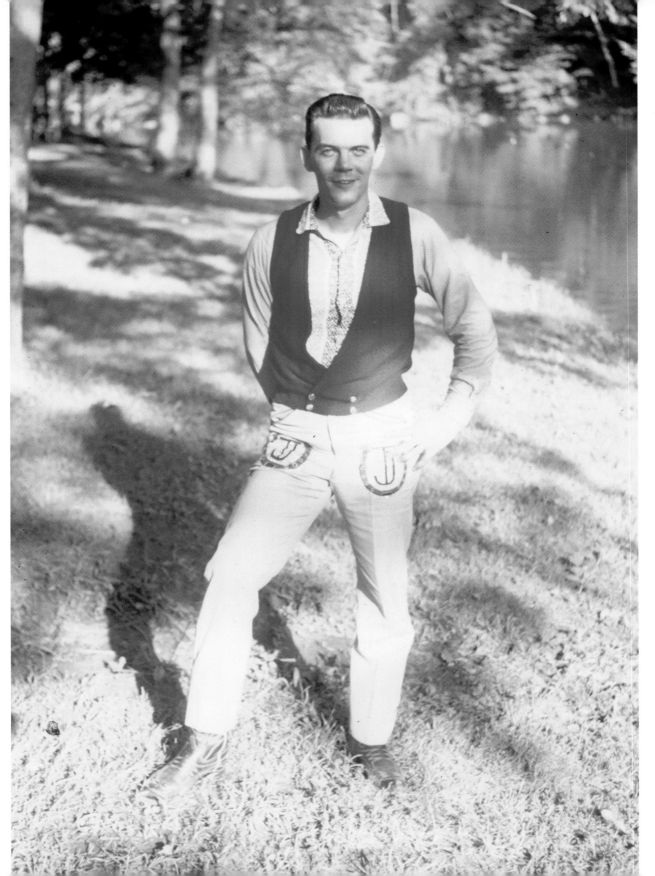

*Justin Tubb*
*NEW RIVER RANCH*
*1961*

## Porter Wagoner

*NEW RIVER RANCH, 1963*

In person, Porter Wagoner was just as friendly and
down-home as he appeared on his syndicated TV show
seen by millions. He proved you could make it big in
Nashville and still be proud you grew up poor as dirt
in the Ozarks. Nobody could seem as natural and at
ease in a Nudie suit, even in the 100-heat of the mid-
day sun, than The Tall Thin Man from West Plain. His
wonderful ode to Southern hospitality, "Ya'll Come,"
which rode the charts in 1966, could have served
as the theme song for the country-music parks.

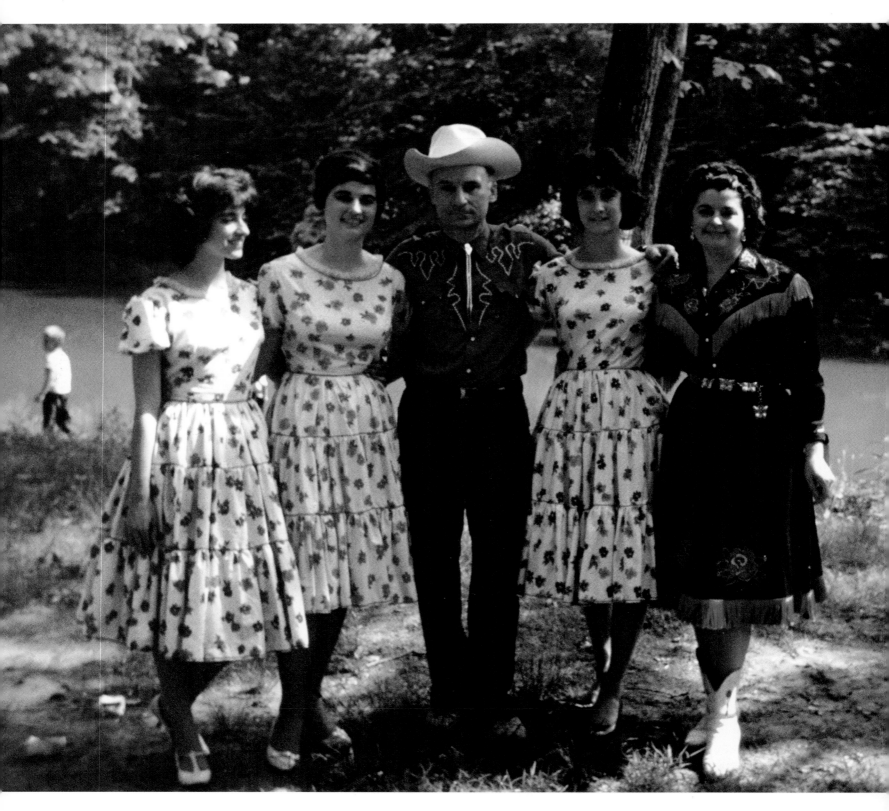

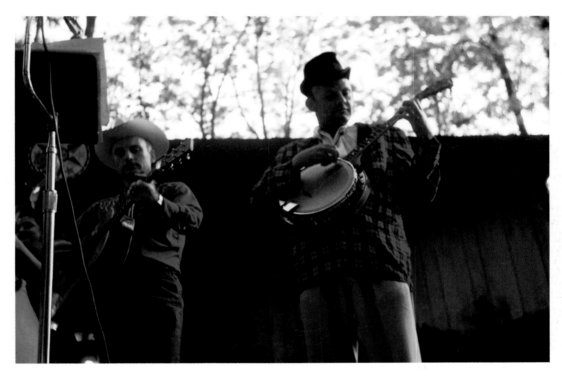

*Doc and Chickie Williams with*
*Peeper, Pooch, and Punkin*
*NEW RIVER RANCH*
*1962*

## Doc and Chickie Williams and the Border Riders

*NEW RIVER RANCH, 1962*

A mainstay on WWVA's Wheeling Jamboree, Doc and Chickie Wlliams, known as "The Girl with the Lullaby Voice," were household names in rural areas from the Southern Appachians to Newfoundland. As toddlers, daughters Barbara, Madeline and Karen joined the show and toured with the family act for years, performing under the stage names Peeper, Pooch and Punkin. Chickie's signature song was her original arrangment of the traditional hymn, "Beyond the Sunset,"covered by Hank Williams.

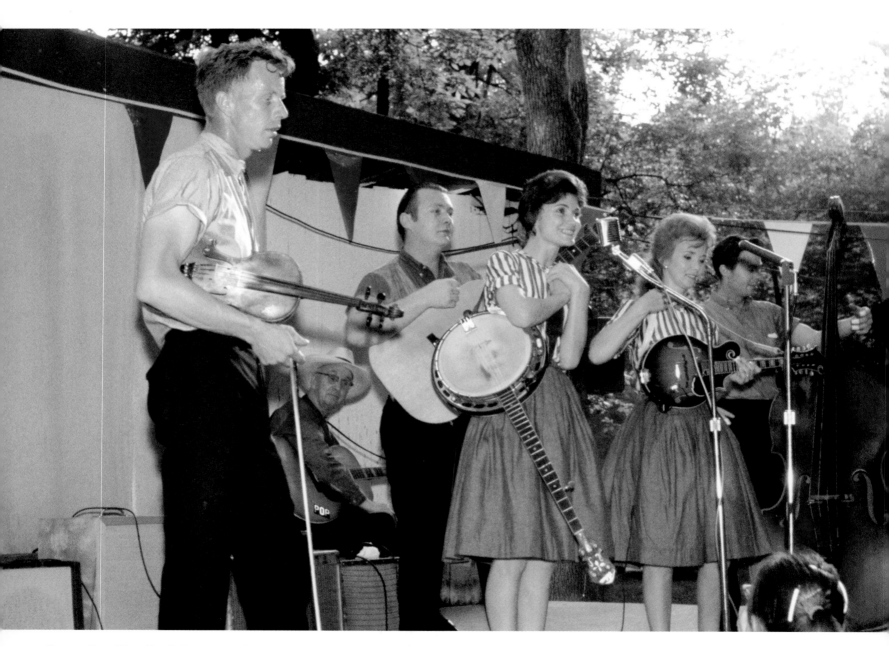

*Scotty, Pop, Van, Roni, Donna, and Jimmy Stoneman*
*NEW RIVER RANCH*
*1963*

# ❧THE STONEMANS❧

Of all the country performers Leon chronicled with his camera and recorder, the Stonemans remained closest to his heart.

In this prodigiously talented clan of displaced Virginia hillbillies, he found a family that won his undying love and devotion second only to his own kin. The Stonemans transformed their ongoing domestic drama into an entertaining and electrifying stage show, making art out of the precarious anarchy of their lives. Leon was not only their most loyal fan, he became a trusted family friend, the only instance where he was able to break through the barrier that always separated him from his idols.

With the Stonemans, there was the solemn, kindly patriarch, Ernest, known to everyone as "Pop," not only one of the first country musicians to record in the 1920s, but one who helped discover the Carter Family and Jimmie Rodgers at the historic Bristol Sessions, which gave birth to the modern country-music industry. Then there was his wife Hattie, singer and old-time banjoist and mother of 23 children, among them Scotty Stoneman, the wild-man fiddler who inspired a generation of fiddlers before dying at 43 of acute alcohol poisoning; Donna, a blonde beauty who rivaled Bill Monroe as bluegrass' finest mandolin player; her sister, Roni, a mountain-style clawhammer banjo master and comedienne who would later star in *Hee Haw*; and Jimmy Stoneman, who played with taped fingers to keep the blood off the strings of his bass fiddle and an epileptic whose on-stage seizures had onlookers at the Monterey Pop festival mistaking his fits for drug-induced Dionsysian frenzy.

Pop was both ringleader and participant in the '50s and '60s, and it was his influence and musical direction that made a Stoneman performance unlike any other in county music. Pop had worked the old vaudeville circuit, and the whole show was like a vaudeville act, a three-ring circus constantly in motion. Sometimes, the family members formed a semi-circle, trading instruments around the line until each had taken a turn on the others', never missing a beat. Spurned by the Nashville establishment (many say it was professional jealousy due to the fact they could out-pick anyone in Music City), the Stonemans always found a home at New River Ranch and Sunset Park.

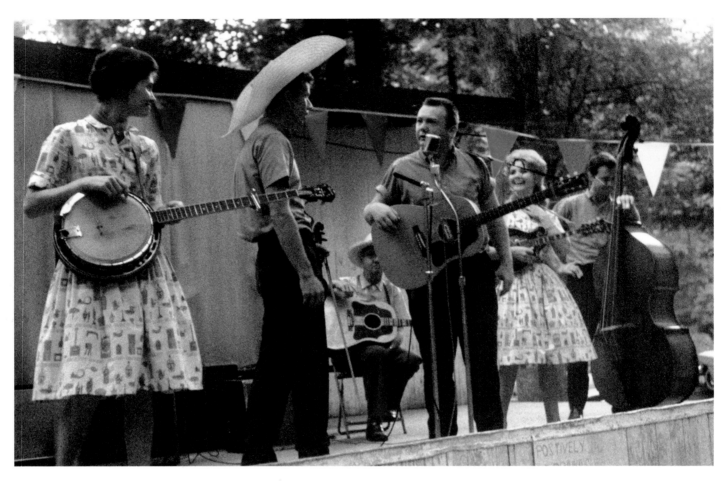

*Stonemans, New River Ranch, 1963*

What the Stonemans lacked in fame and fortune, they made up for in friendliness, which was all Leon needed to feel at home in their world. Pop often helped Leon set up his recording equipment at the shows, flattered that anyone would go to the trouble to record them live. Donna and Roni would flirt with the shy youngster in their innocent backwoods way, stoking Leon's infatuation with the pretty Donna and her fancy on-stage footwork.

> *When she played the mandolin, she danced.*
> *She couldn't play without dancing and*
> *she would jump in the air a foot. And*
> *coincidentally she was one of the best*
> *mandolin players who ever lived. I was*

> *talking to Bill Monroe at Sunset Park*
> *and he said to me that in a contest with*
> *the mandolin Donna Stoneman would win*
> *against him. He said, 'Donna's better than*
> *me.' That was his estimate and Bill Monroe*
> *was the King of Bluegrass.*

What touched Leon above all was the never-ending struggle the Stonemans had to endure in the cutthroat music business despite their talent and showmanship.

> *They were the sweetest people in the world*
> *and they were very poor. They deserved*
> *so much more than what they got, both in*

*money and in fame. They should have been
extremely famous because they were all such
good pickers and they cut so many roads so
many places. They were playing everywhere,
they were playing for nothing and they were
so much better than everyone else for such
a long time. But they were just country
people, they didn't know how to behave, they
weren't politically motivated in any way
and they didn't seem to care about the fame
or anything, they just enjoyed their music.
It makes me so mad when I see histories
on country music and they always call
the Carters the "First Family of Country
Music," because the Stonemans were the first.
And if 13 kids ain't a family, I don't know
what is. They were the first. Pop was first.
I'm sorry. Let's get that straight, world.*

Leon considered it one of the greatest honors of his life
when he was invited to attend Hattie's 70th birthday
celebration at the Stoneman house in Gaithersburg,
MD. For him, it was the ultimate confirmation that he
was truly welcome in the family circle. As usual, he
carried his camera and recorder along, documenting
the event.

*There was a whole flock of people there,
and they were all Stonemans but me. I was
invited because I had taken some of Pop's
original recordings from the '20s and put
them on tape. So I took an amplifier, and I
played Pop's old music for everybody and
they hadn't heard that for more than 20
years. They were all excited. It meant a lot
to them.*

In February 2008, Pop Stoneman was inducted into
the Country Music Hall of Fame.

*Pop Stoneman*
*NEW RIVER RANCH*
*1962*

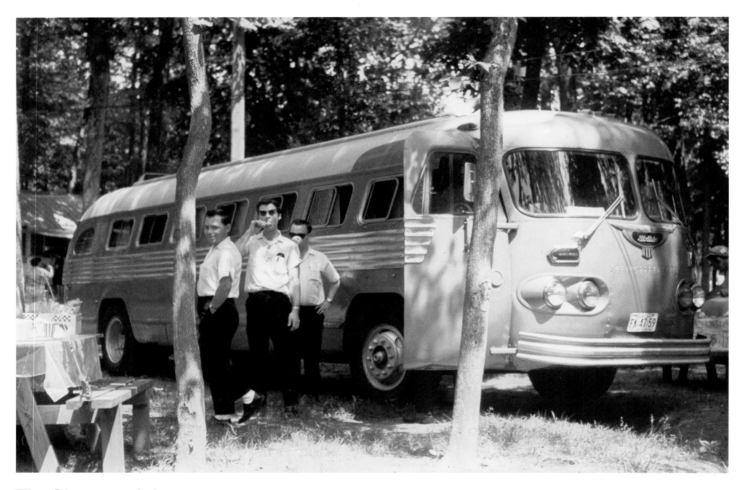

## The Stoneman's bus

*NEW RIVER RANCH, 1962*

The 1949 Flxible bus carried the Stonemans back and forth across the country several times in the early '60s as the surging Folk Revival helped the family band secure gigs at venues from midwestern college campuses to The Mint club in Las Vegas. By December '64, their fortunes were once again on the ebb, and their beloved bus was repossessed with the family $1,500 arrears in payments.

*Roni and Donna Stoneman*
*NEW RIVER RANCH*
*1962*

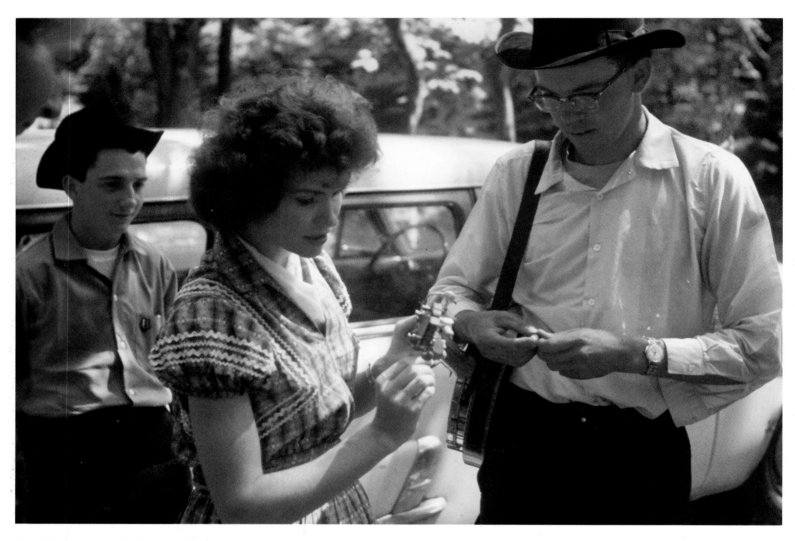

Roni Stoneman with Mennonite fans
*NEW RIVER RANCH*
*1962*

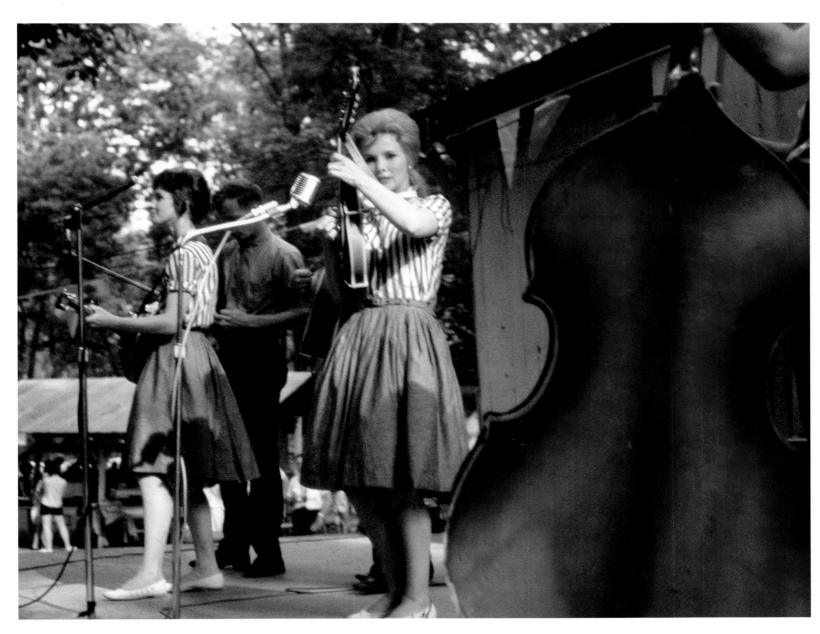

*The Stonemans*
*NEW RIVER RANCH*
*1963*

## Roni and Donna Stoneman

*NEW RIVER RANCH, 1963*

The Stoneman sisters, Roni (left) and Donna were more than
country stars for Leon. They were his muses, and he worshipped
the ground they walked on. When they played and sang and
danced on stage, they made him feel happy to be alive.

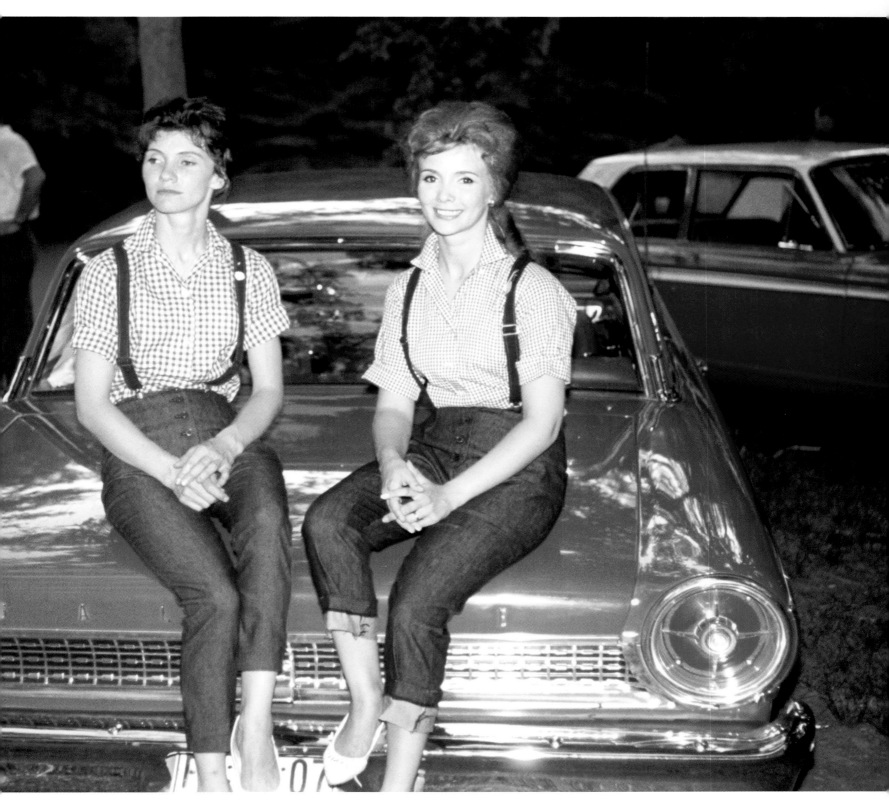

*Donna Stoneman*
NEW RIVER RANCH
AND SUNSET PARK

*Roni Stoneman*
*NEW RIVER RANCH*
*1963*

Donna Stoneman
NEW RIVER RANCH
1963

*Roni (holding Leon's 8mm camera) and Donna Stoneman*
*NEW RIVER RANCH*
*1963*

# Mike Seeger

*SUNSET PARK, 1963*

A scion of America's first family of folk music, Mike Seeger was a frequent interloper at Sunset Park and New River Ranch, not only as a documentarian but as a participant. His NYC-based revivalist group, the New Lost Ramblers, was crucial in bridging the cultural gap between the rural roots of old-time music and its new urban hipster devotees like Bob Dylan. Seeger's recordings of the Stonemans in the '60s are vital documents of a hillbilly family scratching out a living in the big city.

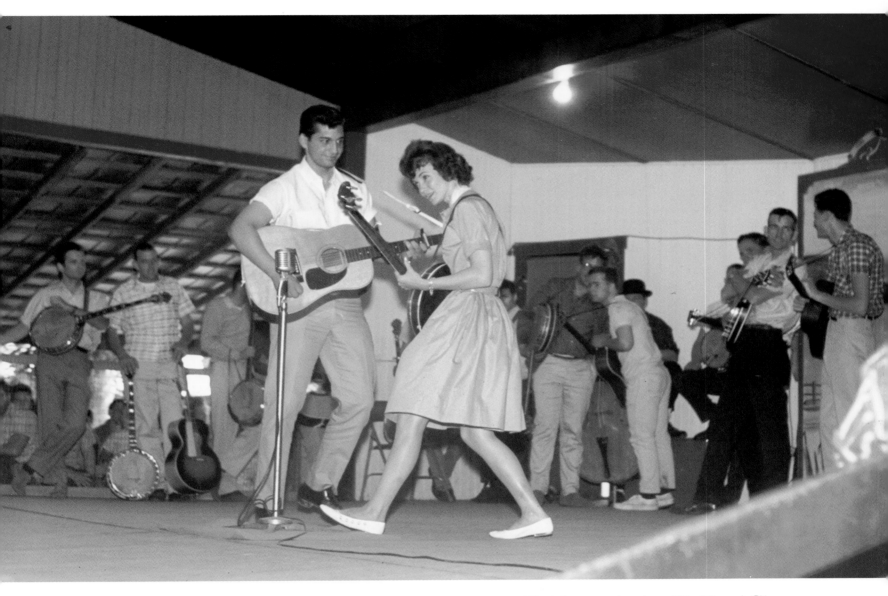

## Banjo contest with Roni Stoneman

*SUNSET PARK, 1963*

The annual Fourth of July Banjo Contest was always a big draw at Sunset Park, allowing amateurs to take the stage against professionals in a free-for-all battle of the five-string. The winner received an Earl Scruggs model banjo. Though she was most known as a wise-cracking comedienne who played Ida on *Hee Haw*, Roni Stoneman was one of bluegrass' finest pickers and she took top honors in the contest depicted here at Sunset.

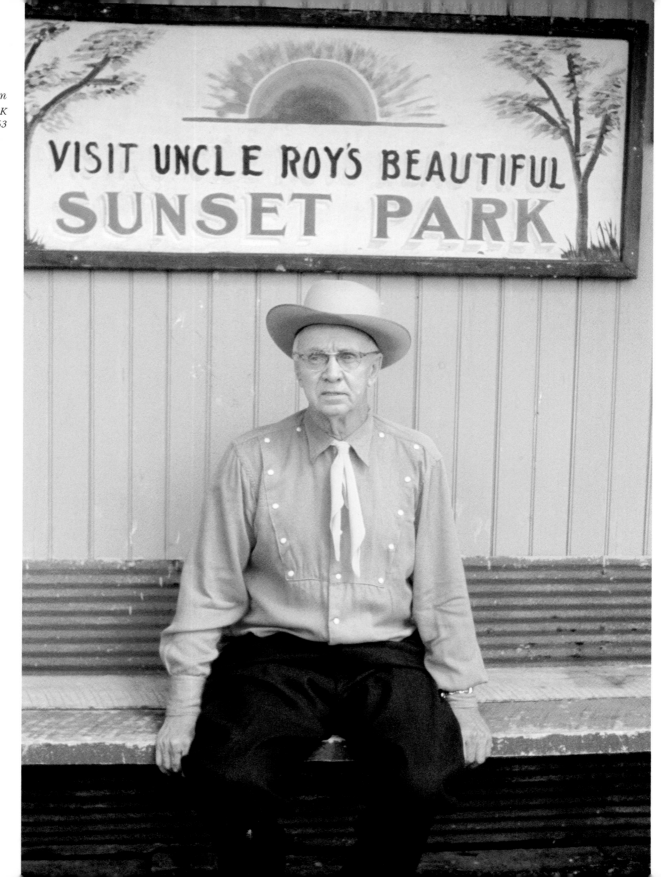

Pop Stoneman
*SUNSET PARK*
*1963*

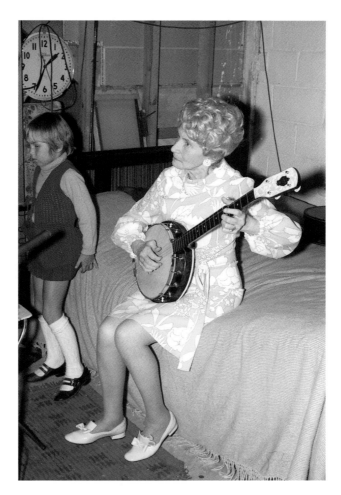

*Hattie Stoneman and granddaughter*
*HATTIE'S BIRTHDAY PARTY*
*Gaithersburg, MD*
*1970*

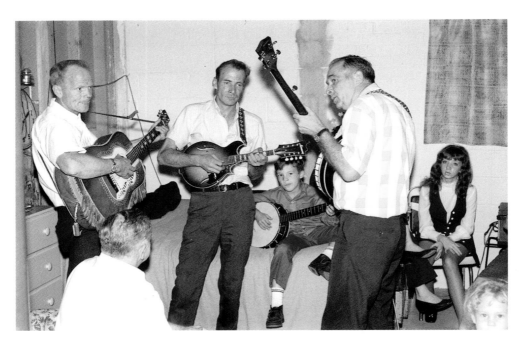

*Stoneman family members*
*HATTIE'S BIRTHDAY PARTY*
*Gaithersburg, MD*
*1970*

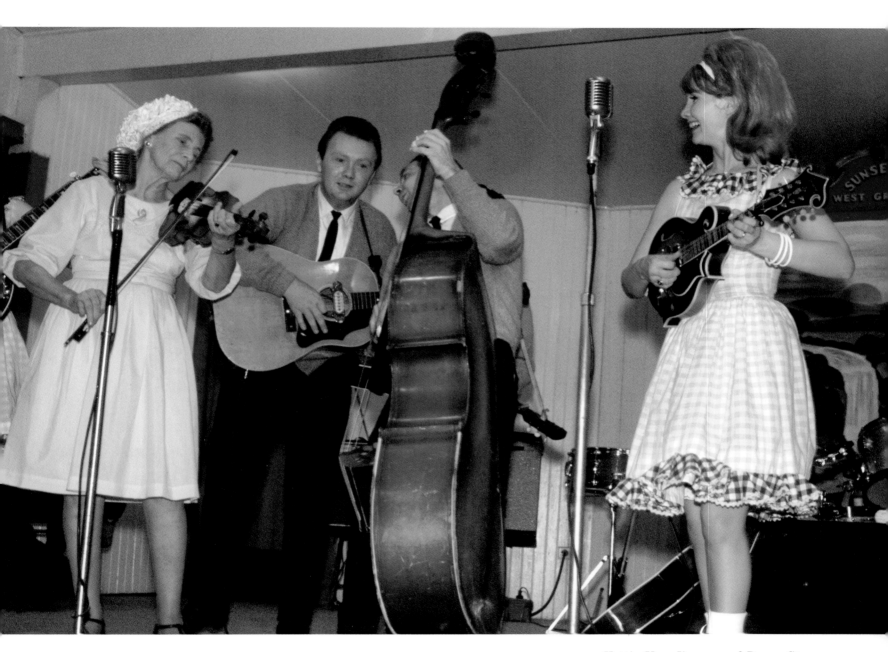

*Hattie, Van, Jimmy, and Donna Stoneman*
*SUNSET PARK*
*1966*

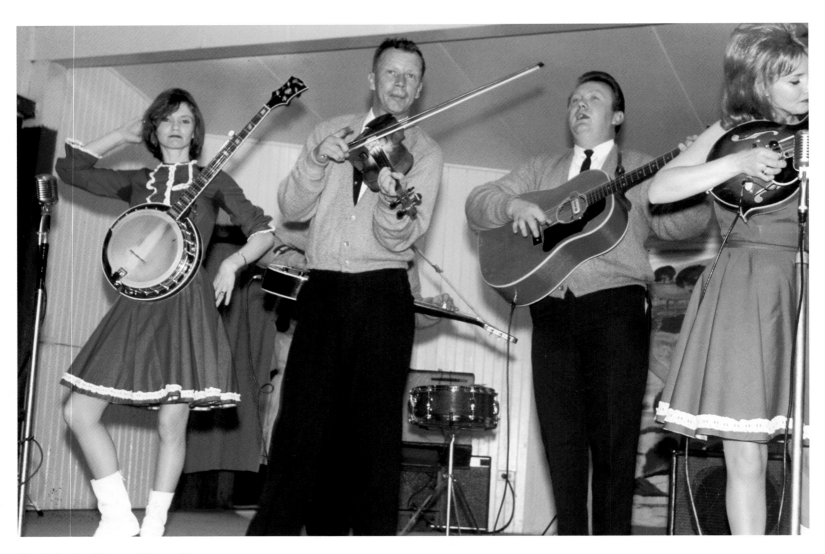

*Roni, Scotty, Van, and Dona Stoneman*
*SUNSET PARK*
*1966*

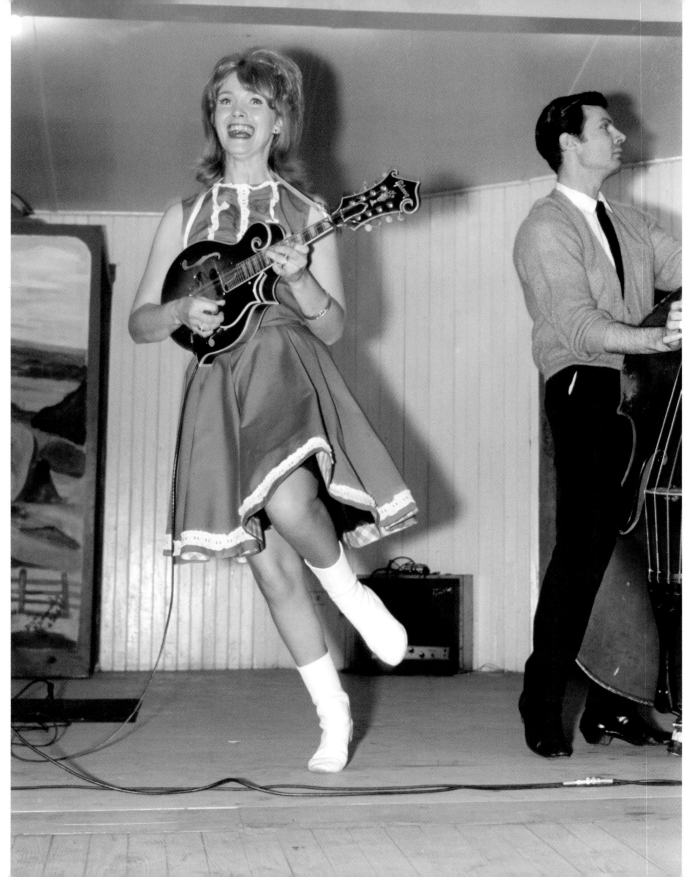

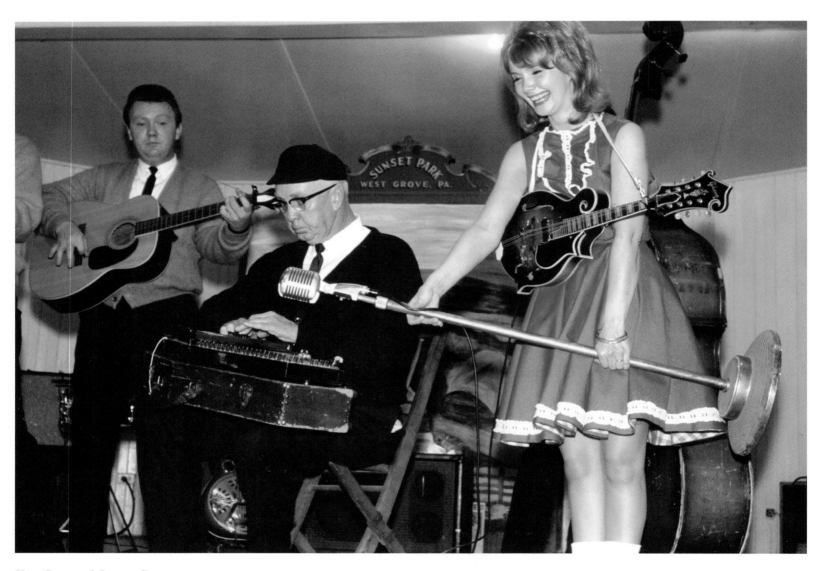

*Van, Pop, and Donna Stoneman*
*SUNSET PARK*
*1966*

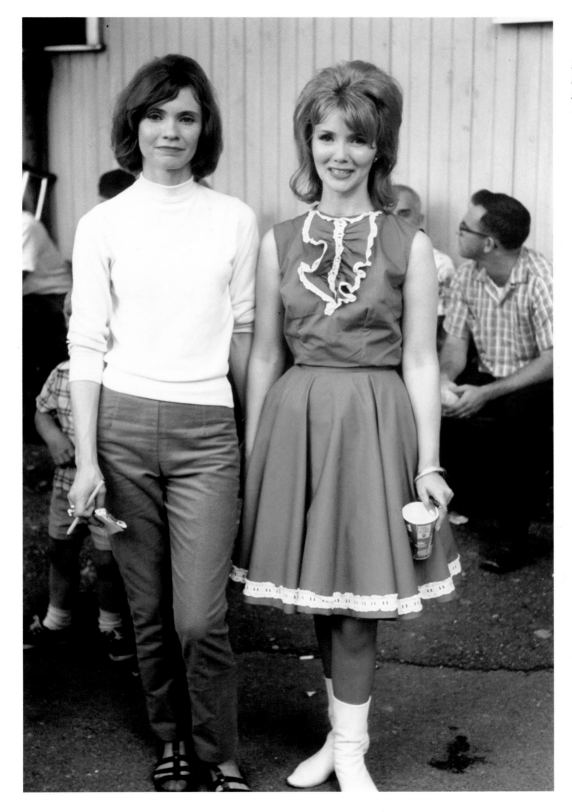

## Don Owens

*BALTIMORE, MARYLAND, 1960*

In the wake of the rock revolution, nobody did more to keep country music alive and kicking in the Washington-Baltimore area than Don Owens. A fine bluegrass performer himself, he was the epitome of the promoter as super-fan. He treated the musicians like brothers and sisters, and he had evangelical zeal in spreading the gospel of hillbilly music to transplanted Southerners who made the DC metro area second only to Nashville as a country-music market. Leon religiously taped the *Don Owens TV Jamboree Show* off the cathode tube of his television set until Owens' death in a late-night car crash in 1963.

It was a show that gave country music the utmost respect but wasn't afraid to celebrate its rural roots with generous helpings of cornball humor.

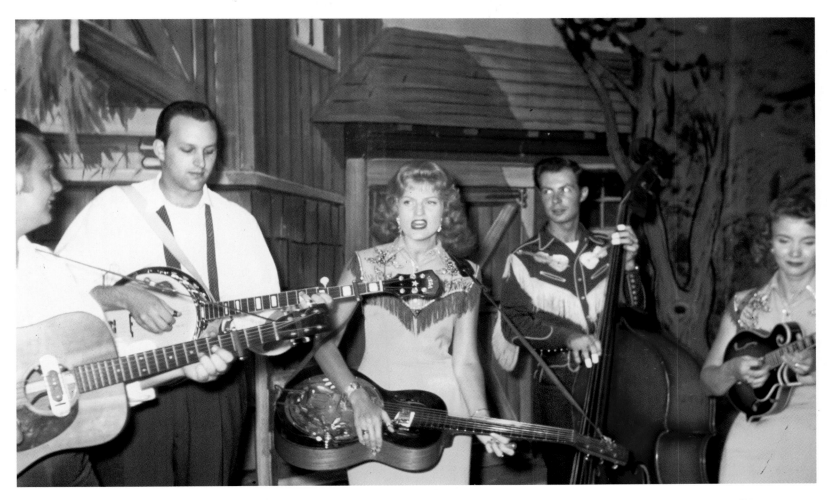

## Bluegrass Champs

*VAN STONEMAN, BILL EMERSON, PEGGY STONEMAN, JIMMY STONEMAN, DONNA STONEMAN*

*SUNSET PARK, 1960*

Without Pop, the Stonemans performed as the Bluegrass Champs, and they were Leon's favorite band of all. Fiddler Scott Stoneman inspired pickers from Jerry Garcia to Richard Greene, and his on-stage prowess, including mesmerizing solos that took flight for ten minutes and more, are the stuff of legend.

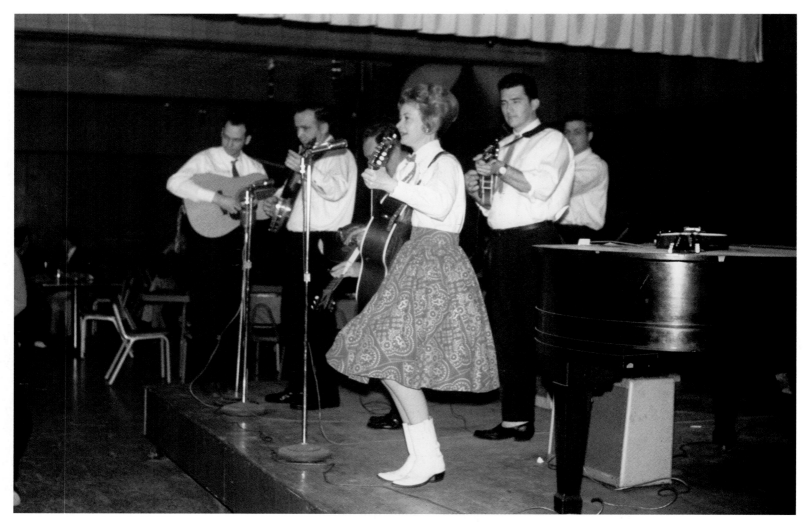

# Dairyland

*PATSY STONEMAN WITH HER BACKUP BAND*

*JESSUP, MARLYAND, 1964*

*At Dairyland the Stonemans played different music. They didn't tell as many wild jokes, they had to cool it, I guess, because they had a different crowd. It was actually a beer hall, but they had a huge dance floor and people would dance as they were playing music, so they played a lot more ballads and they played for maybe eight or ten minutes per song, whereas at other places they would play for half that. They played a lot more of the old favorite songs because that was the crowd; it wasn't a particularly country music or bluegrass crowd, it was just a crowd of people who liked to dance.*

*Dairyland patrons*
*1963*

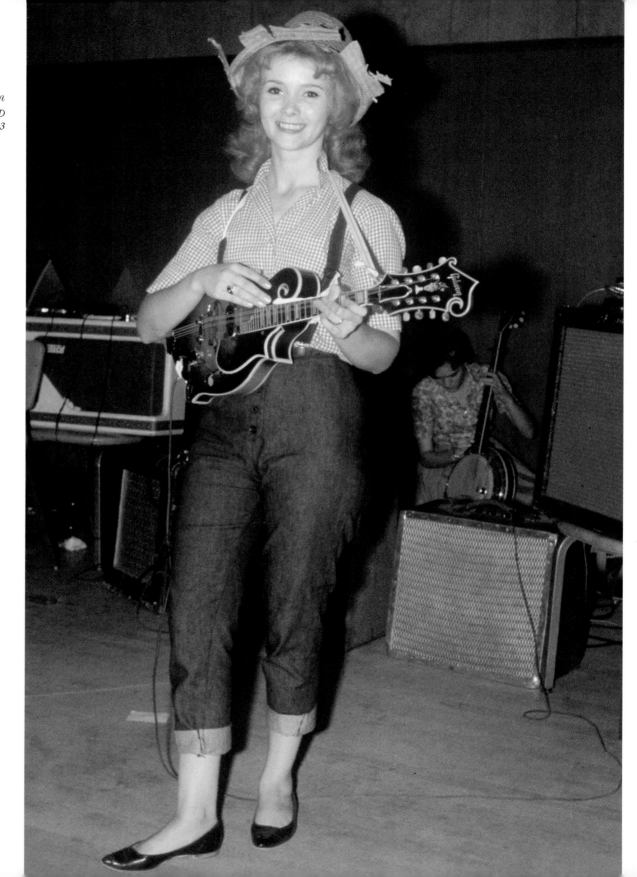

*Donna Stoneman*
*DAIRYLAND*
*1963*

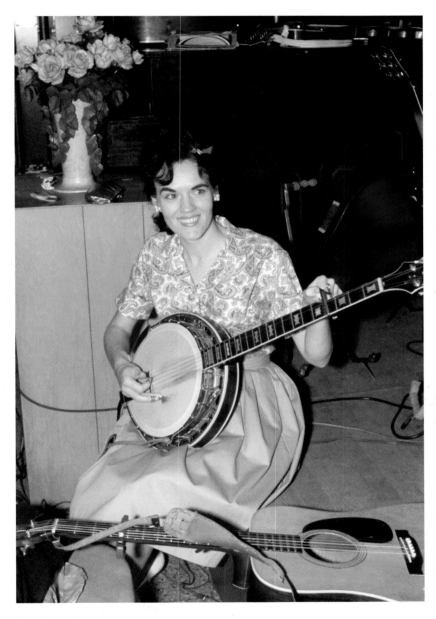

## Betty Amos

*DAIRYLAND, 1963*

A veteran of the wild and wooly Carlisle Brothers act in the '50s, Betty Amos could hold her own on a stage with anybody in Nashville. Her female truck-driving record, "Eighteen Wheels A-Rollin'," on Leon's beloved Starday label, was a jukebox favorite in the '60s.

SUNSET PARK

ON ROUTE 1 betw. WEST GROVE & OXFORD, PA.

SUN. AUG. 1

LORETTA LYNN

AND THE NASHVILLE TENNESSEEANS

POSTERS INC., 539 N. 11th St. Phila., Pa. 19182 • Phone: WA 5-2000 (215)

SUNSET
PARK
ON ROUTE 1 Betw. WEST GROVE & OXFORD, PA.

SUN. AUG. 31
IN PERSON
PORTER
WAGONER
AND THE
WAGONMASTERS
WITH
DOLLY PARTON

POSTERS, INC. 533 N. 11th St., Phila., Pa. - 19123

*113*

# ❖SUNSET❖

SUNSET PARK, WEST GROVE, PA

On his record-hunting expeditions in the remote Southern outback and at New River Ranch's deep woods setting, Leon saw first-hand the terrain that birthed and nurtured country music, yet in these rustic environs he remained an outsider. It was at Sunset Park where his journey came full circle to a place where he was truly at home.

Everything here felt familiar to him: the welcoming vistas of open farmland, the local Pennsylvania Dutch of his own heritage who loved polkas along with pedal-steel guitars, and the spacious eight-acre park itself, set against the western horizon in a field adjacent to a farmhouse where the owners lived. Here was a sense of permanence, rooted in family and community, that few other country-music parks could boast. Even as New River Ranch, which closed in the early '60s, lay in ruins in the tangled woods where it had arisen, Sunset Park flourished for more a half-century as a haven where hospitality ruled, for the stars and fans alike.

Sunset was already nearly two decades old when Leon first began attending shows here, its tin-roofed stage built to last against the elements, constructed of sturdy tongue-and-groove fir by local Amish carpenters. Here Leon found all God's plenty, as the park's entertainment included novelty and vaudeville acts of every stripe: dancing troupes and magicians and acrobats. There was Little Ashley, "the world's smallest midget," the blackface comedy duo, Smokey and Henry, and a local phenom, Ray Myers, the "Armless Wonder," who smoked cigarettes with his toes and played steel guitar with his feet.

It was a place where, for at least a few hours each Sunday, people tried to live by the Golden Rule. A backstage sign made it clear the entertainers were held to the same high standards, providing explicit warning to all performers: "No Profanity (Not Even a Hell or Damn) Allowed On This Stage In Any Show. KEEP YOUR SHOWS CLEAN—

NO SMUT. Please refrain from cussing backstage as Microphone is always open. Thank You."

While some venues, such as Watermelon Park in Virginia, were known for rowdy gatherings that sometimes exploded into knife fights and shootings, Sunset Park inspired a peaceful ambience, as one performer put it: "There was something about the park that made you a different person when you were there. Part of it was the family-picnic type of environment and plus, it's such pretty country up there, so clean and nice." Patsy Cline may have played the beer joints and fire halls in her red short-shorts, but at Sunset she was on her best behavior in G-Rated garb such as the fringed cowgirl outfits her mother sewed for her back home in Winchester.

At Sunset, all was forgiven and everyone was welcome. Kicked off the Grand Ole Opry, Hank Williams rode into the park in his shiny Cadillac like an exiled king, and performed for $900, big money at the time. Ola Belle and Alex Campbell, former owners at New River, became the house band at Sunset after their park closed down, another example of the neighborliness that exemplified the close-knit scene.

At Sunset, not just Leon but the country music he loved had found a sanctuary that was out in the open, laid bare to the crossroads hamlet of West Grove, PA. The sign with the painting of a D-28 Martin guitar (the instrument of choice for every self-respecting bluegrass picker) high on a pole at 102 Kelton-Jennersville Road told the world that here was a mecca for the traditional country music done the old tried and true way. Flushed out from the backwoods hideaway of New River, the stars strutted the grounds for all to see in their spangled Nudie suits, proud as peacocks in front of the more ordinary barnyard fowl represented by the flocking fans.

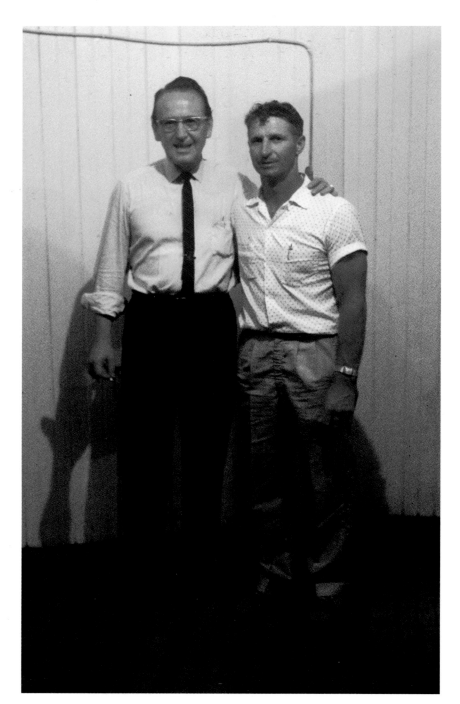

*Red Foley and Lawrence Waltman*
*SUNSET PARK*
*1961*

Here were Mennonites and urbanites, down-home country-folk and hipster folkies, all come together in the spirit of the music.

Everybody and their brother played Sunset at one time or another, often long before stardom flicked its pixie dust. One of Leon's favorite shows was a late-'60s performance by Dolly Parton, when she debuted her classic, "Coat of Many Colors," about her girlhood growing up poor in east Tennesee, a song that resonated with the audience, many of whom had similar upbringings in the Southern hills. "She was very, very country back then," Leon recalled. "She sat down on a stool and played solo, just Dolly and her guitar. There wasn't a dry eye in the crowd." The tape of this show was later stolen from his home by a Parton fanatic and former friend of Leon's.

Sunset Park's owners, Lawrence and Hazel Waltman, often hosted musicians in their farmhouse next to the facilities. Hazel would often fry ham and eggs for performers who had shows booked the next day in Baltimore or Philly or somewhere further north. Jimmy Martin, the hard-living,

hard-boozing, self-described King of Bluegrass, would always have his special request, fresh milk from the dairy barn, bottled up to go. The noon-to-night schedule was set up so that local farmers could see the afternoon show, go home, milk the cows and eat supper, and come back to see the evening show.

The communal vibe spilled into the parking lot, close by the fenced-in grave of park founder 'Uncle" Roy Waltman, where informal jam sessions had area musicians fresh out of the fields mixing with counterculture pilgrims such as Jerry Garcia, a 21-year-old banjoist from California whose dream at the time was to be one of Bill Monroe's Bluegrass Boys.

Though Leon made his final photos in the '70s, Sunset survived for another quarter-century. As always, the park offered shows rain or shine, with its covered stage and pavilion enclosed by its Quonset-style tin roof. When it closed in 1995, 'Uncle Roy's Beautiful Sunset Park," in the words of its stage-side sign, had lasted almost as long as the Grand Ole Opry.

# SUNSET ☼ PARK

## ON U.S. RT. 1 BETWEEN WEST GROVE AND OXFORD

**SUNDAY, APRIL 27**

**Don Reno - Bill Harrell**
& the TENNESSEE CUT-UPS

**Shorty Nesbitt**
& the WRANGLERS

Alex, Ola Belle & the New River Boys & Girls

**SUNDAY, MAY 4**

**Jimmy Martin**
& the SUNNY MOUNTAIN BOYS

**Jim Nichols**
& the KEYSTONE PLAYBOYS

Alex, Ola Belle & the New River Boys & Girls

**SUNDAY, MAY 11**

**Carl Butler & Pearl**

**Johnny Berry**
& the MASON-DIXON BOYS

Alex, Ola Belle & the New River Boys & Girls

**SUNDAY, MAY 18**

**Loretta Lynn**
& the NASHVILLE TENNESSEANS

**The Buck Benson Show**

Alex, Ola Belle & the New River Boys & Girls

**SUNDAY, MAY 25**

**Jim & Jesse**
& the VIRGINIA BOYS

**Jim Greer**
& the MAC-O-CHEE VALLEY GANG

Alex, Ola Belle & the New River Boys & Girls

**SUNDAY, JUNE 1**

**Connie Smith**
& HER SUNDOWNERS

**Del McCoury**
& the DIXIE PALS

Alex, Ola Belle & the New River Boys & Girls

**SUNDAY, JUNE 8**

**The Osborne Bros**

**Mel Price**
& the SANTA FE RANGERS

Alex, Ola Belle & the New River Boys & Girls

**SUNDAY, JUNE 15**

**Tompall**
& the GLASER BROS.
FOR THEIR FIRST APPEARANCE HERE

**Lee Edmond**
& the COUNTRY STRINGERS

Alex, Ola Belle & the New River Boys & Girls

**SUNDAY, JUNE 22**

**Dottie West**
& the HEARTACHES
HER FIRST APPEARANCE HERE

**Sterl Sauble**
& the RHYTHM KINGS

Alex, Ola Belle & the New River Boys & Girls

FIRST SHOW AT 1:00 P.M.

ADMISSION $1.50

CHILDREN UNDER 12 FREE

# SUNSET ☀ PARK

## ON U.S. RT. 1 BETWEEN WEST GROVE AND OXFORD

---

**SUNDAY, JUNE 22**

### Carl Smith, Columbia Recording Artist from Nashville, Tenn.

**Steryl Sauble**
& the RHYTHM KINGS

Alex, Ola Belle & the New River Boys & Girls

**SUNDAY, JULY 13**

### The Stonemans
SINGIN' SWINGIN' AND STOMPIN'

**Warren Mercer**
& the ROYAL RAMBLERS

Alex, Ola Belle & the New River Boys & Girls

---

**SUNDAY, JUNE** ⬦

K⬦ Wells
& the J⬦ SHOW

⬦nn

Alex, O⬦ ⬦oys & Girls

**SUNDAY, JULY 20**

### Bill Monroe
& the BLUE GRASS BOYS

### Teenie Chenault
& the COUNTRY ROCKERS

Alex, Ola Belle & the New River Boys & Girls

---

**FRIDAY,** ⬦

"The Ke⬦ Wonder"
ANNUAL 5 STR⬦ BANJO CONTEST
**Prize: "Scruggs ⬦odel Vega Banjo"**

Alex, Ola Belle & the New River Boys & Girls

**SUNDAY, JULY 27**

### Hank Williams, Jr.
& the CHEATIN' HEARTS

### The Tex Carson Show

Alex, Ola Belle & the New River Boys & Girls

---

**SUNDAY, JULY 6**

### The Bill Anderson Show
WITH JIMMY GATELY & JAN HOWARD
WITH MAGIC & ILLUSIONS

Alex, Ola Belle & the New River Boys & Girls

**SUNDAY, AUG. 3**

### The Drifting Cowboys
THE ORIGINAL BAND OF HANK WILLIAMS, SR.

### Lloyd Arnold
& the ROCKIN' DRIFTERS

Alex, Ola Belle & the New River Boys & Girls

---

ADMISSION $1.50, TAX INC.     CHILDREN UNDER 12 FREE

## Connie Smith

*SUNSET PARK, n.d.*

Connie Smith was a young
housewife when she was
discovered at a talent show
in Ohio, and the pretty
blonde songbird took
Nashville by storm in 1964
with her hit, "Once a Day."
For Leon, she represented
not only the ideal female
vocalist but the epitome of
Christian womanhood.

*To my mind, she had the
best voice of any female
country singer I ever heard.
It just sent chills up and
down my spine. She was
about as good as Patsy
Cline. That's how good she
was. Her voice is fabulous
and she's a very wonderful
person. She was a Christian,
and that helps, that I like.*

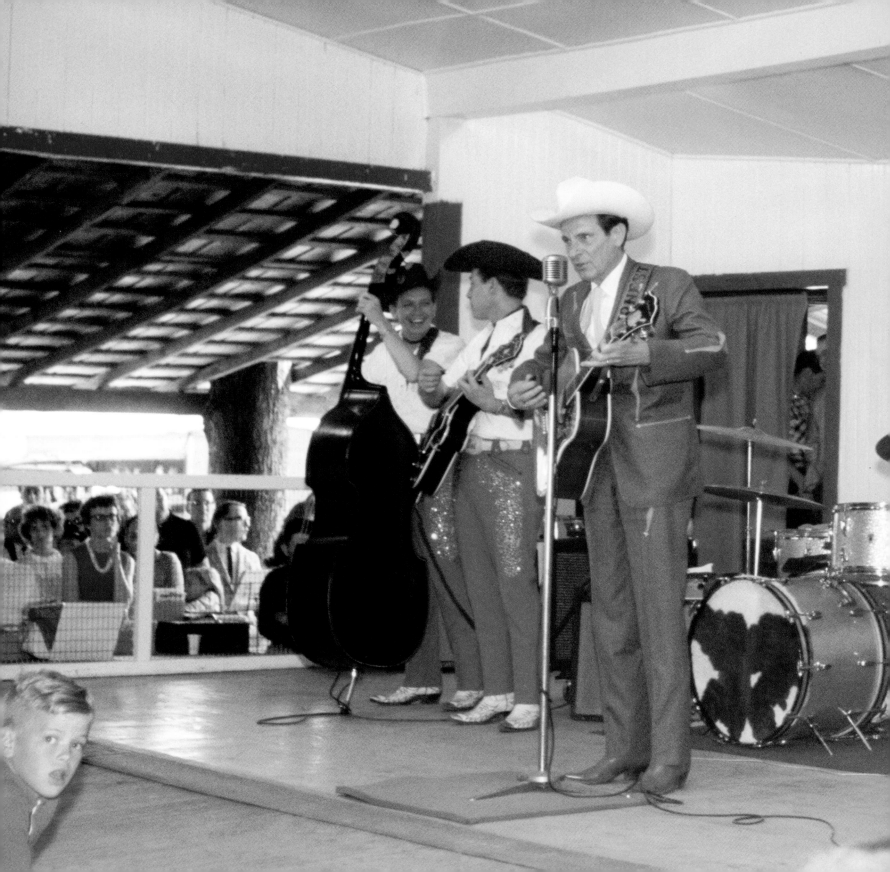

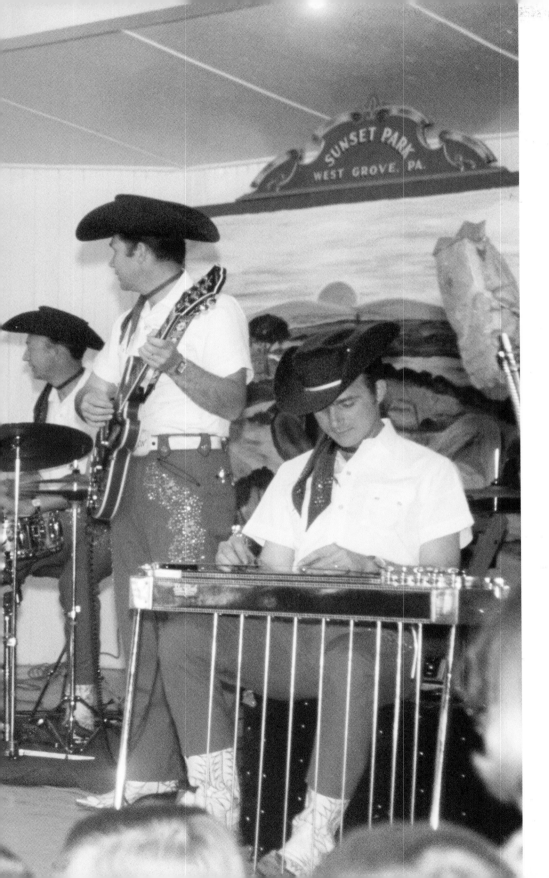

## Ernest Tubb

*SUNSET PARK, 1964*

The Texas Troubadour, Ernest Tubb, first played Sunset Park in 1944 and he made it a regular stop on his never-ending tour back and forth across the country. His motto was "Don't forget the people. They're the ones that put you here." When he finished a set, "E.T." would twirl his guitar in his hands to show the crowd the backside emblazoned with the word "THANKS," a reference not only to his hit "Thanks a Lot," but to the gratitude he felt toward the fans who made him one of the biggest country stars of the postwar years.

By the '60s, though his star was on the wane, he never lost the sparkle that gave his brand of honky-tonk a glow of good will and neighborliness.

*His loyalty to his fans was just unheard of. Some of his shows would go 'til 9 o'clock at night or later. It was pitch dark and he had to go hundreds of miles back to Nashville, and there would be a long line of people waiting to get autographs, and his band members were saying, "Let's go, let's go" but he wouldn't go. He would stay for hours until the last autograph was signed. That's how Ernest Tubb was.*

SUNSET **PARK**

on RT. 1 Betw. WEST GROVE & OXFORD, PA.
▼▼▼▼▼▼▼▼▼▼▼▼▼▼▼▼▼

# SUN. JULY 18

▼▼▼▼▼

**IN PERSON**

# KITTY WELLS

WITH THE

# JOHNNY WRIGHT SHOW

POSTERS INC. 835 Cherry St., Phila., Pa. WAlnut 5-2000

## Kitty Wells

*SUNSET PARK, 1963*

Kitty Wells, the Queen of Country Music, whose landmark 1952 million-seller, "It Wasn't God Who Made Honky-Tonk Angels," opened the door for female country singers in Nashville.

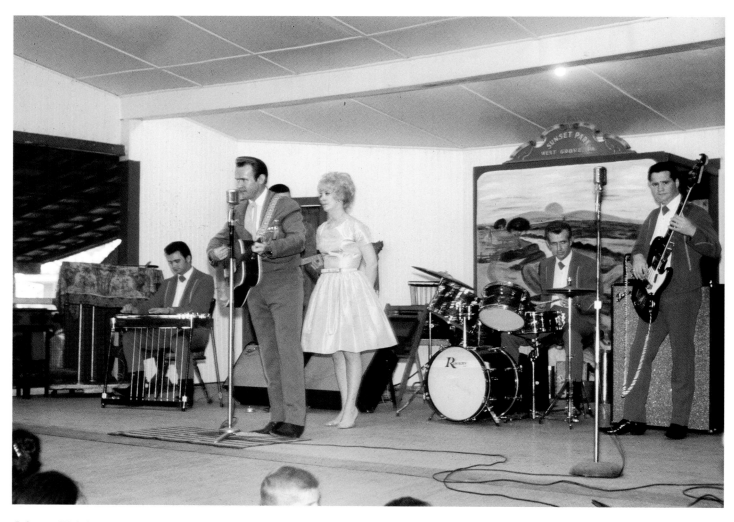

*Johnny Wright*
SUNSET PARK
1968

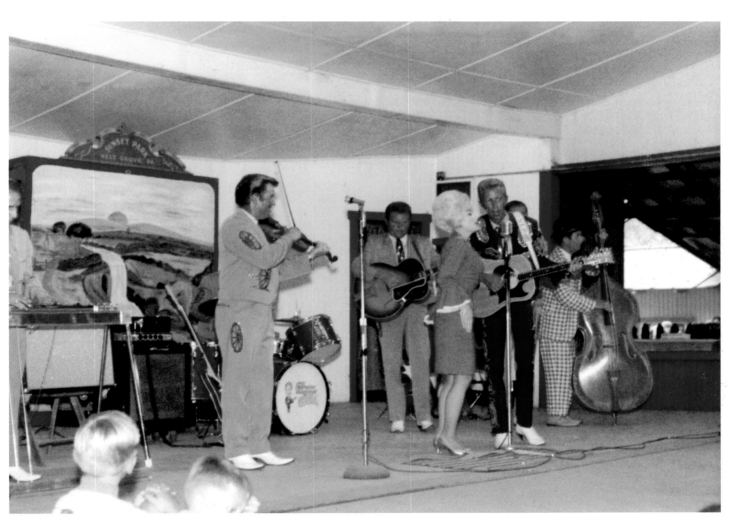

*Dolly Parton and Porter Wagoner*
*SUNSET PARK*
*1968*

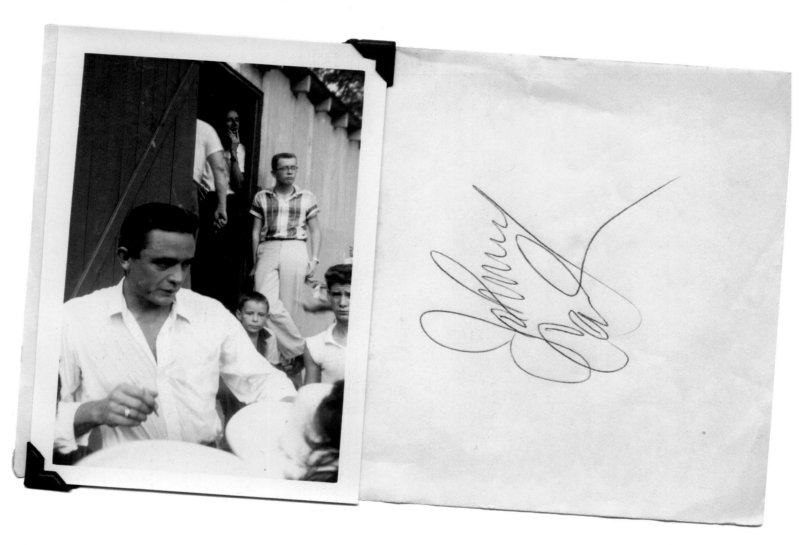

## Johnny Cash and autograph

*SUNSET PARK, 1961*

The Man in Black dressed in white for his show at Sunset, and he delivered a garbled, Benzedrine-laced monologue on-stage before losing his voice during the last set. He ended up in a local hospital and had to cancel his appearance at the nearby York Fair.

## Bill Anderson

*SUNSET PARK, 1966*

Though he came from relative comfort a long way from any farm, Whisperin' Bill Anderson empathized with the hardscrabble lives he celebrated in his 1961 hit "Po Folks," which told the story of many in the crowds at Sunset Park and New River Ranch: "My daddy was a farmer but all he ever raised was us."

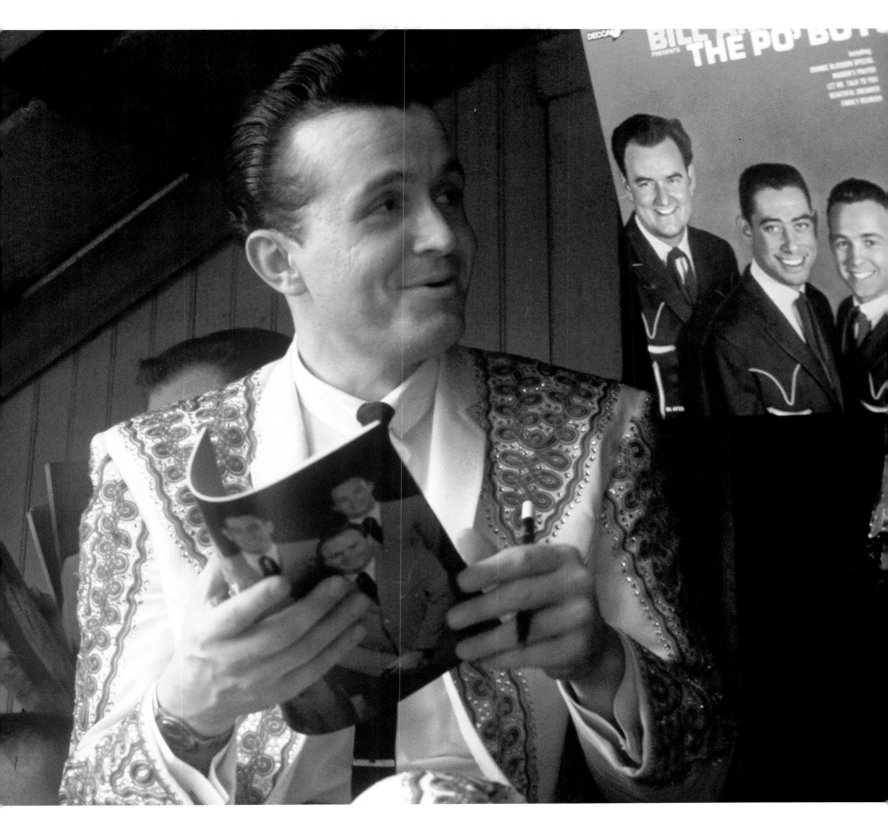

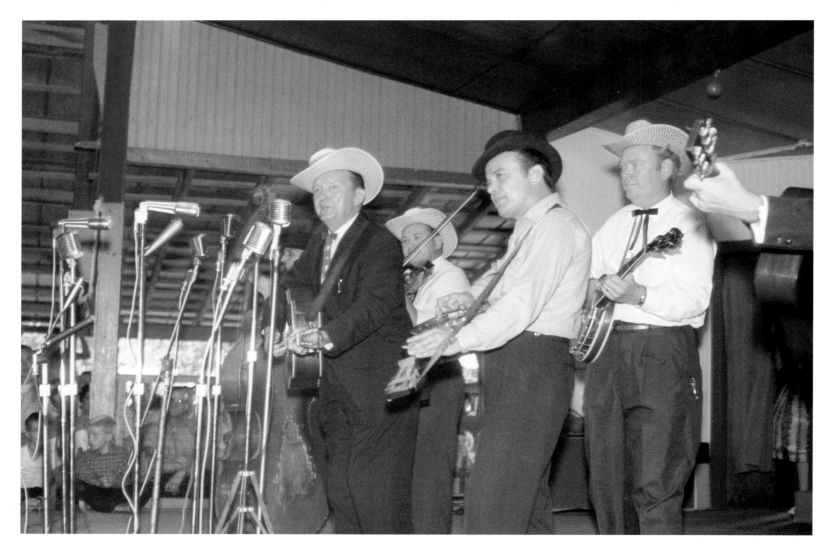

## Lester Flatt

*SUNSET PARK, 1962*

Lester Flatt's, deadpan vocals found a national audience with "The Ballad of Jed Clampett," theme song for the *Beverly Hillbillies* TV show. But even the biggest bluegrass stars like Flatt spent much of their careers scratching out a living on the country-music park circuit. As Flatt once told a promoter after getting paid for a show: "Barely enough."

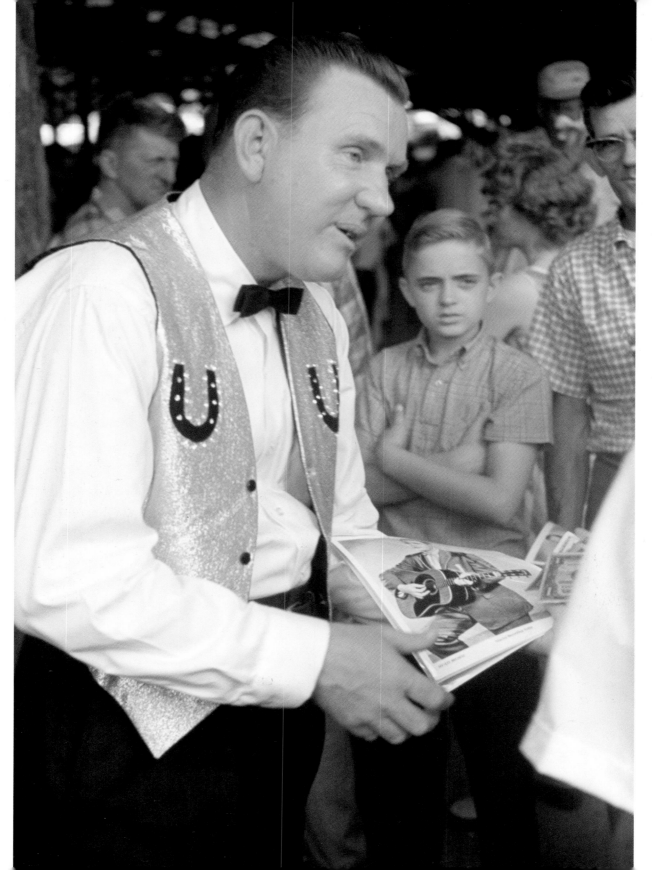

## Hank Snow

*SUNSET PARK, 1964*

From the squid-jigging grounds of Nova Scotia, the Singing Ranger made his American stage debut at Sunset Park in 1950. For the next decade, Snow enjoyed a steady stream of monster hits like "I'm Movin' On," "The Golden Rocket," and "A Fool Such As I." He was a small, wiry man with a big booming voice, warm and inviting as an old potbellied wood-stove. By the '60s, he was a one of Nashville's power brokers and ruling elder statesmen, full of bluster and short of temper. He once fired a fiddler whose bow accidentally nudged Snow's toupee off in front of a crowd. "But the joke was he was so rich. I mean the guy was big, and you could see a mile away it was a hairpiece. Couldn't he have gotten a better hairpiece? A better piece of grass?"

*Hank Snow*
*SUNSET PARK,*
*1970*

## Jean Shepard

*SUNSET PARK, 1962*

Shepard's ground-breaking 1954 concept album "Songs of a Love Affair," detailed how a woman's perspective on romance wasn't always a pretty picture. Here she autographs a photo of herself and husband Hawkshaw Hawkins, who perished in the 1963 plane crash that also claimed the lives of Cowboy Copas and Patsy Cline.

*June Carter*
LYRIC THEATER, BALTIMORE, MD
*1964*

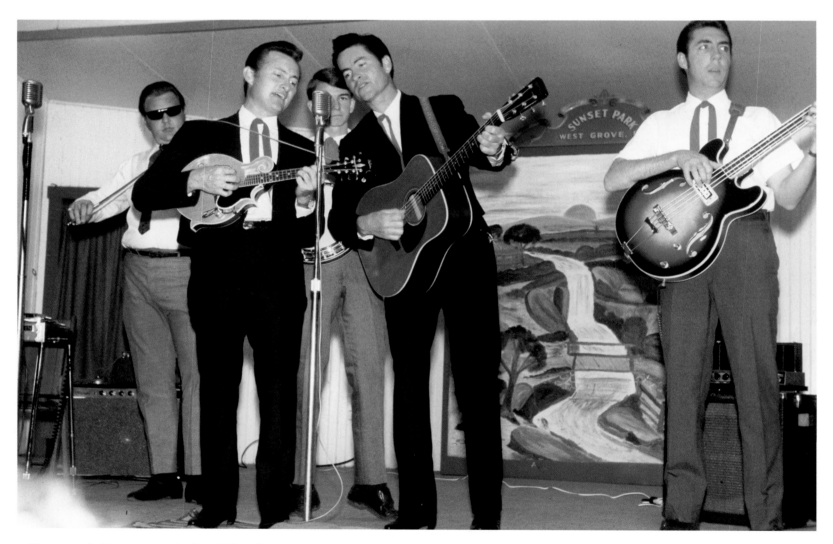

## Jim and Jesse and the Virginia Boys

*SUNSET PARK, 1968*

Jim and Jesse McReynolds were mountain boys unafraid to take on the big wide world, whether it be recording a 1965 tribute to Chuck Berry, *Berry Pickin' in the Country*; making a cameo on a Doors album, as Jesse did when he lent his mandolin picking to The Soft Parade; or packing an electric bass, as in this show at Sunset Park. Through it all, they stayed together longer than any brother act around.

SUNSET
**PARK**
ON ROUTE 1 Betw. WEST GROVE & OXFORD, PA.
SUN. MAY 25
IN PERSON
JIM &
JESSE
AND THE
VIRGINIA BOYS
POSTERS, INC. 533 N. 11th St. Phila. Pa. 19123

*Smitty Ervin*
*SUNSET PARK*
*1965*

## Bill Harrell

*SUNSET PARK, 1961*

A frequent collaborator
with Buzz Busby, Bill
Harrell is well remembered
by fans for the singles
he cut for Starday in the
early '60s with his band
the Virginians, mossy
old bluegrass classics
like "Eating Out of Your
Hand." Harrell knew the
hillbilly bars of Washington
DC only too well. He
often played the Famous
on 14th St. and New York
Ave. for tips in a pitch pot,
which was a galvanized
trash can. Once a woman
threatened her cheating
husband by holding a gun
next to his head as Harrell
sang a few feet away, and
another time Harrell nearly
drowned an unruly sailor
in the bathroom toilet.

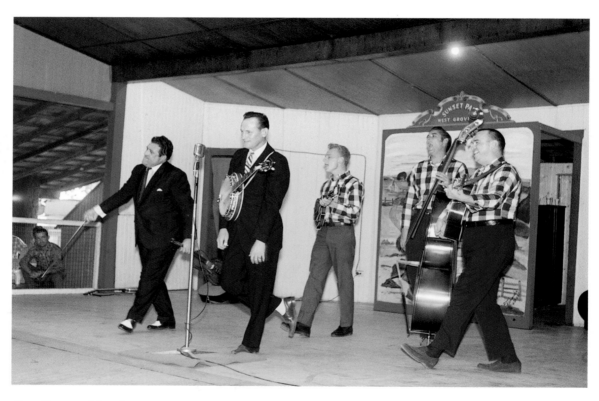

*Don Reno and band*
*SUNSET PARK*
*1967*

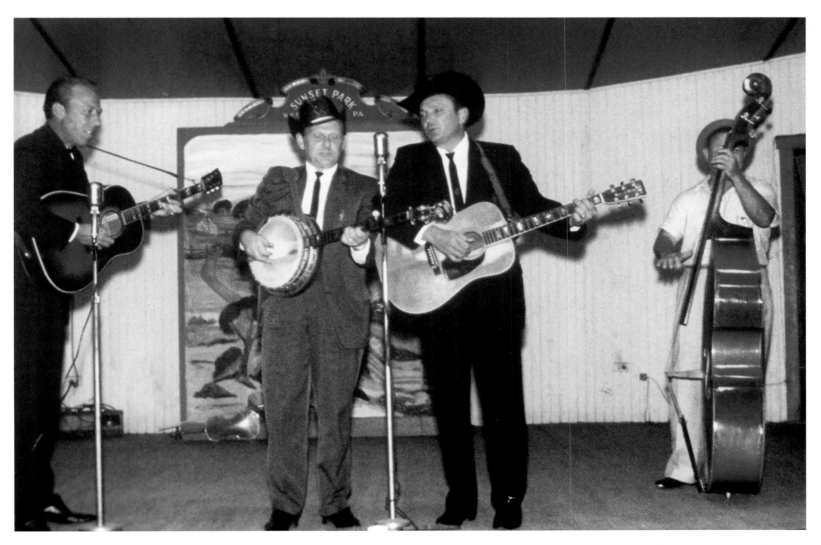

## The Stanley Brothers

*SUNSET PARK, 1964*

The haunting, mournful harmonies of Ralph, left, and Carter Stanley were known as the "graveyard sound," and no country singers before or since knew their away around an old-time mountain hymn like the brothers from the Clinch Mountains in far southwest Virginia. George Shuffler (far left) was such a fixture in the band he became known as the third Stanley Brother, and his cross-picking guitar added a soulful depth to the Stanleys' late, autumnal sound.

# Ola Belle Reed, Deacon Bromfield, and Alex Campbell

*SUNSET PARK, 1966*

Without a solid house band, a venue even as grand as Sunset Park isn't much more than a bare stage for stars that come and go. For years, Sunset was blessed with the myriad talents of Ola Belle Reed and Alex Campbell and their band, including dobro player Deacon Brumfield. The stars were great, but the New River Gang, well, they were like family.

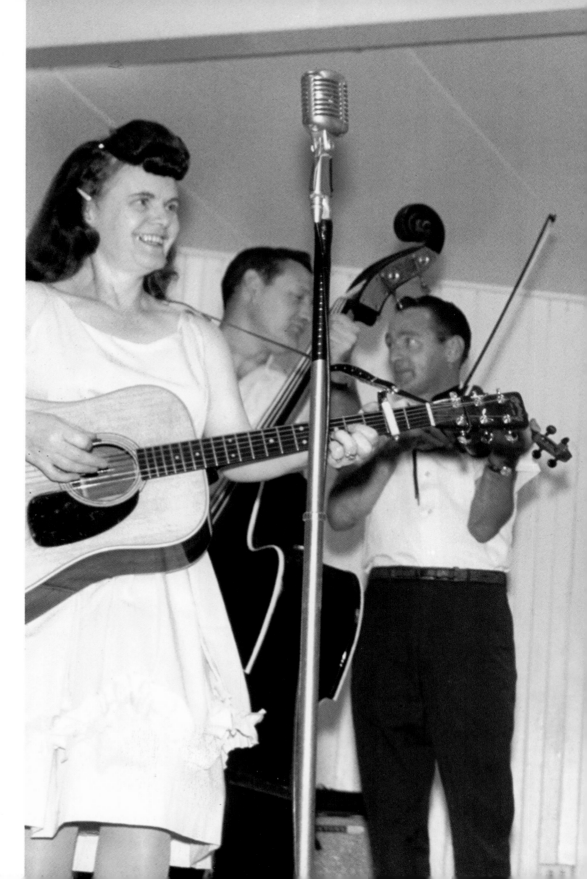

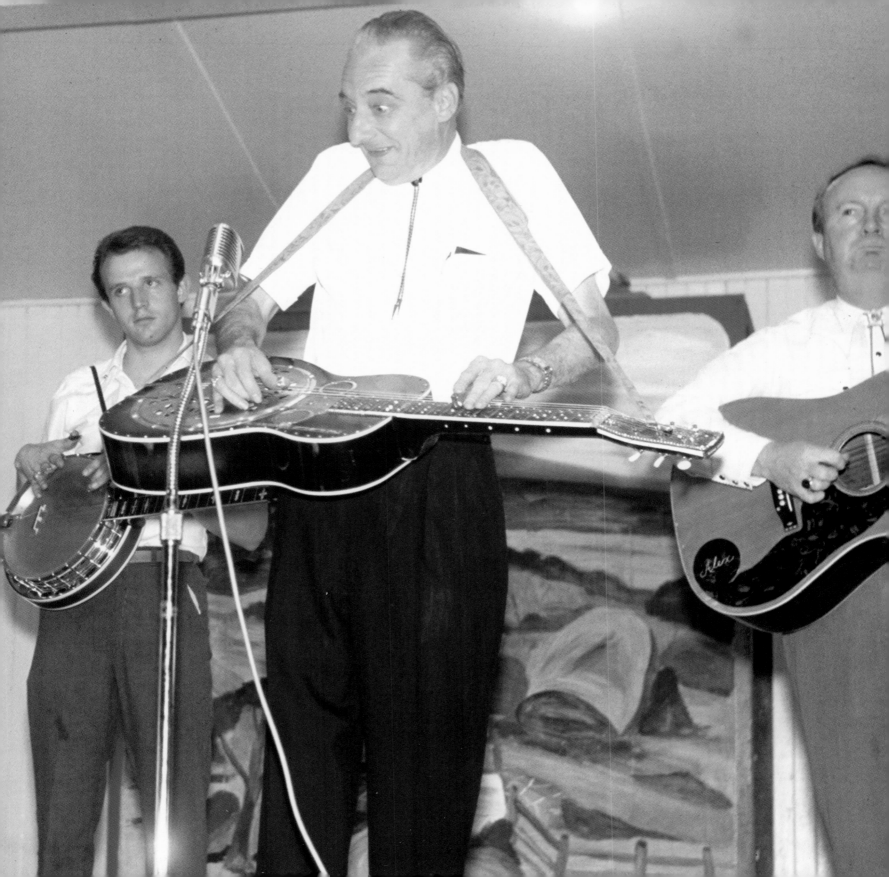

# Pee Wee King

*SUNSET PARK: 1967, 1965*

In its postwar heyday, Music City made stars of hayseeds and farm boys and even an accordion-playing Pole from Wisconsin named Julius Kuczynski who became Pee Wee King. His classic "Tennessee Waltz" sold millions and his Golden West stage-show was a dime-store cowboy fantasia. By the '60s, he'd added The Collins Sisters, two platinum-blonde, leggy nubile twins who pleased Leon right along with most of the male crowd.

They couldn't play a lick but they were sharp with cap-gun pistols and gave King's show an added bang for the buck. The Collins Sisters could pass muster, but what many of the regulars at Sunset Park could not abide was Pee Wee's inclusion of drums. This was rank blasphemy to the traditionalists, who wanted their country music kept pure of such rock-influenced chicanery.

*They'd say, 'What are you doing with those drums? They don't belong here!' They almost chased Pee Wee out of the park. 'We don't want your kind here!' They yelled it real loud and would shame him to death. They did every-thing but throw him off the stage.*

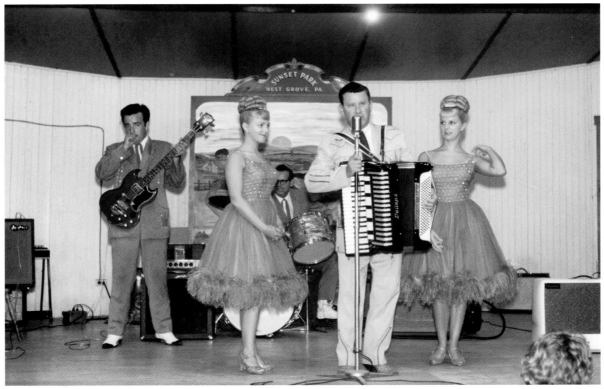

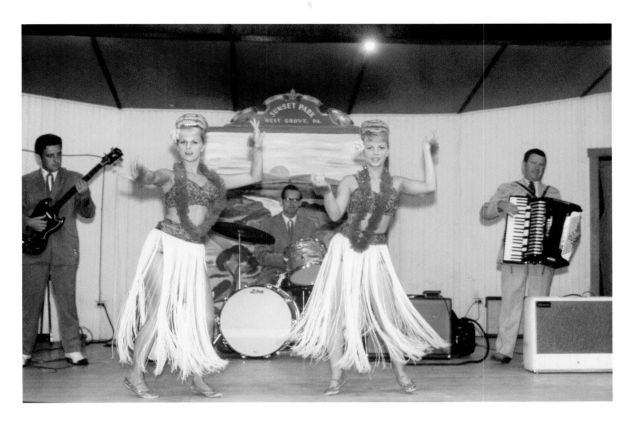

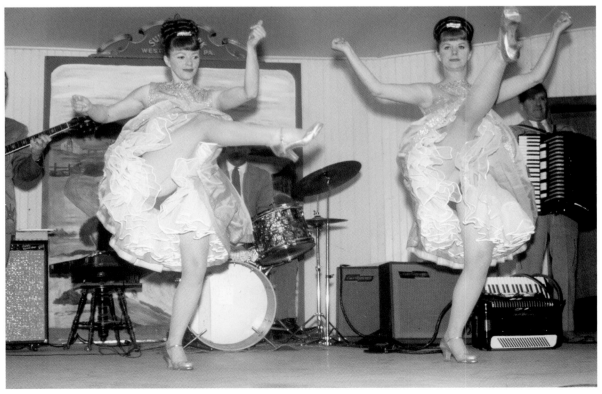

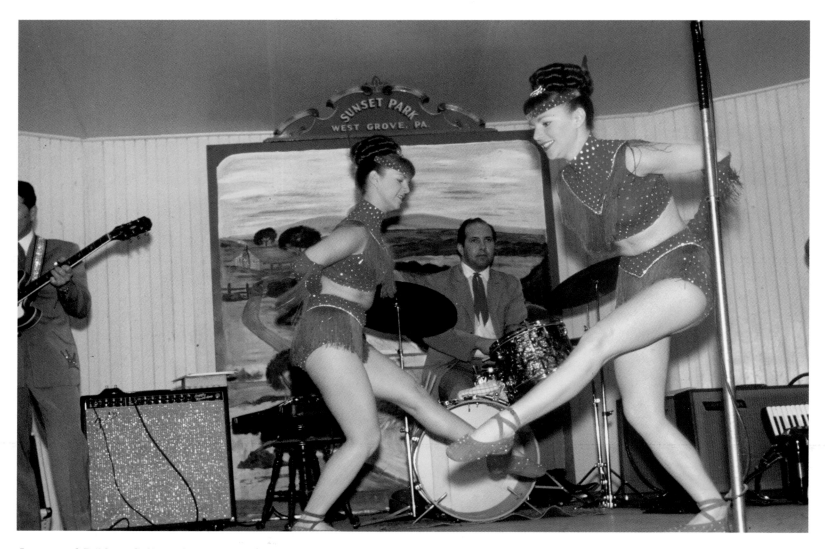

*Joycec and Darlene Collins, dancers for The Pee Wee King show*
*SUNSET PARK*
*1967*

*PREVIOUS SPREAD:*
*Collins Sisters*
*SUNSET PARK*
*Top left, top right, bottom left: 1965*
*bottom right: 1967*

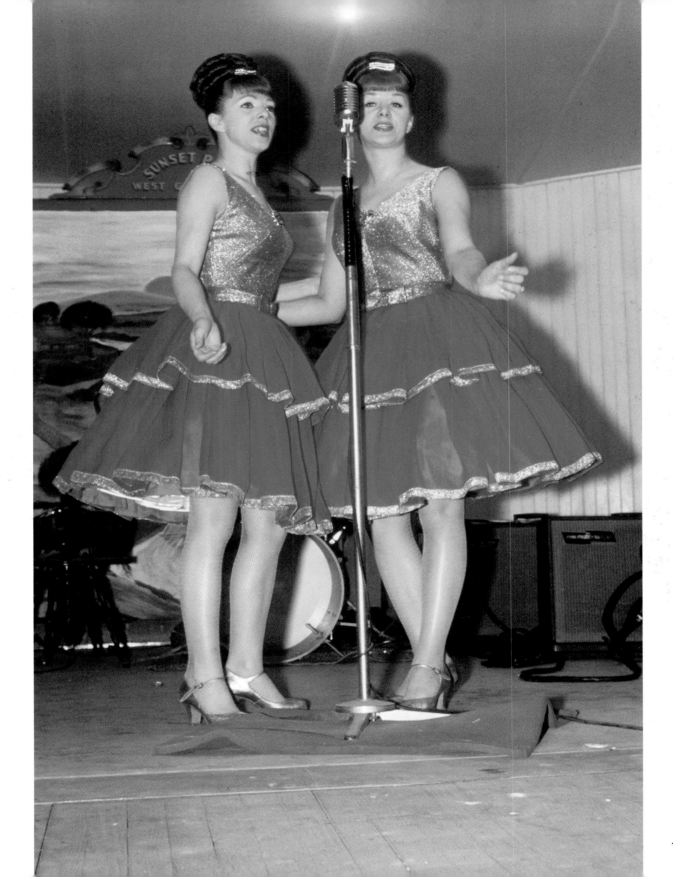

## Wilma Lee and Stoney Cooper

*NEW RIVER RANCH, 1961*

The husband-and-wife team from West Virginia never struck it rich
but they counted wealth in other ways. No couple in country music
took their wedding vows more seriously. When Wilma Lee belted
out "I've Been Cheated, Too," the fans knew she hadn't been, not
really, but she sure sang it like she had. They performed for 35 years
together until Stoney's death in 1977.

*Wilma Lee and Stoney Cooper*
SUNSET RANCH
*c. 1967*

## Amateur Musicians

*SUNSET PARK, 1960s*

Some of the finest
performances happened out
in the parking lot, at the back
of an old pick-up truck or
around a picnic table, where
informal jam sessions sprung
up in small colorful clumps
like mushrooms after a hard
Pennsylvania rain. Here is
where local musicians and
pilgrims came to listen and
learn and play. For most, it
was as close as they would
ever get to the stage at Sunset
Park, but it was close enough.
This was a picker's paradise,
a chance to shine with a solo
and grab a moment of glory
to brag about for years
back home.

*A whole bunch of people
would stand around and
listen, and they would
give requests and some
of the music back there was
as good or better
than what was onstage.
Music was everywhere,
it just proliferated the
whole park.*

*Mary Kagarise (Leon's wife) with her parents, Henrietta Erdman and Adolph Erdman*
*SUNSET PARK*
*1965*

*A Fan*
SUNSET PARK
*n.d.*

*Polly Bailey*
*SUNSET PARK*
*n.d.*

*Polly Bailey (dancer in the Mel Price Show)*
*SUNSET PARK*
*n.d.*

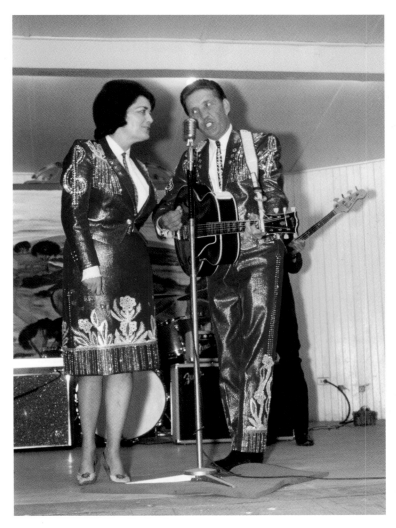

## Pearl and Carl Butler

*SUNSET PARK, n.d.*

With her husband Carl, Pearl Butler sang some of country's saddest and best-selling weepers, "Don't Let Me Cross Over", "Too Late to Try Again," "I'm Hanging up the Phone," and other tearjerkers that struck a chord with country audiences in the '60s. The couple's final chart appearance, "We'll Sweep Out the Ashes in the Morning," from 1969, was later covered by Gram Parsons and Emmylou Harris.

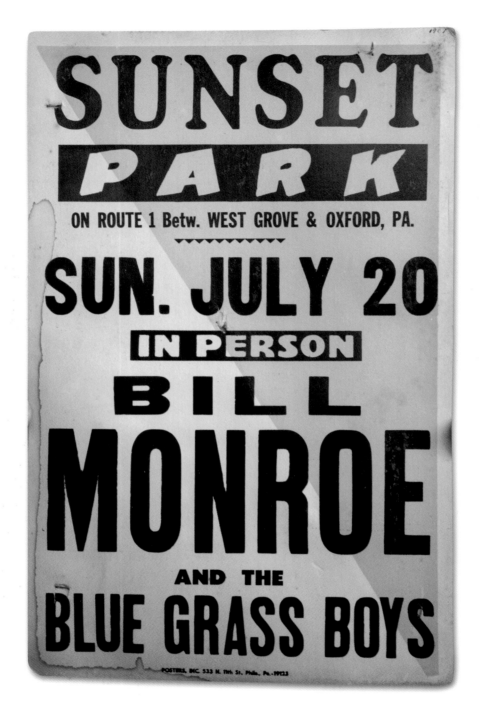

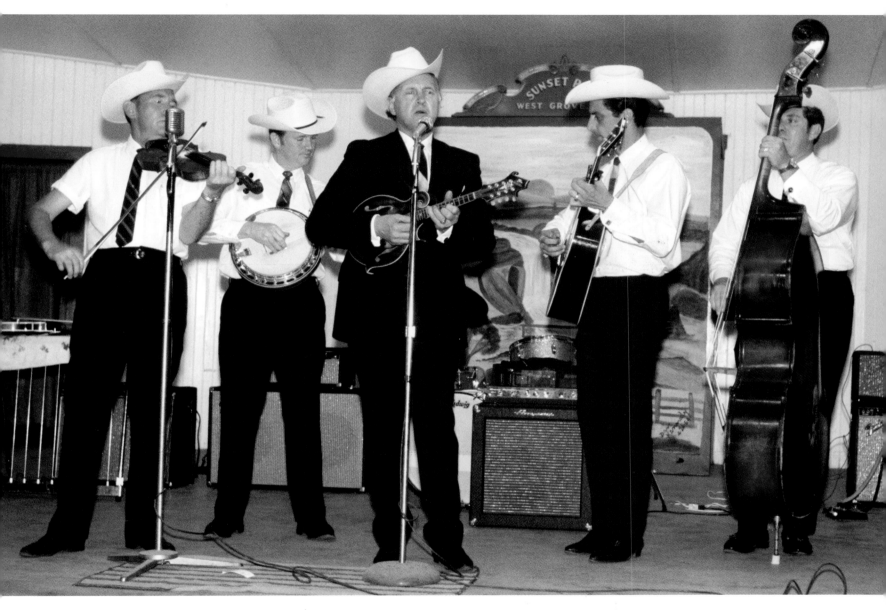

## Bill Monroe

*SUNSET PARK, 1963*

The only performer to ever reprimand Leon for recording a live show was Bill Monroe. It happened out of the blue, without warning, just before the Bluegrass Boys took the stage for a performance, when Monroe walked to the edge of the stage, leaned down while cradling his tiny mandolin and sternly told Leon to pack up his tape machine. Monroe was every bit of solid-barrel-chested six feet tall, and he kept in shape by plowing by horse at his Tennessee farm. Back in the '40s, he once took his entire band on his back just to prove he could do it. Leon obeyed.

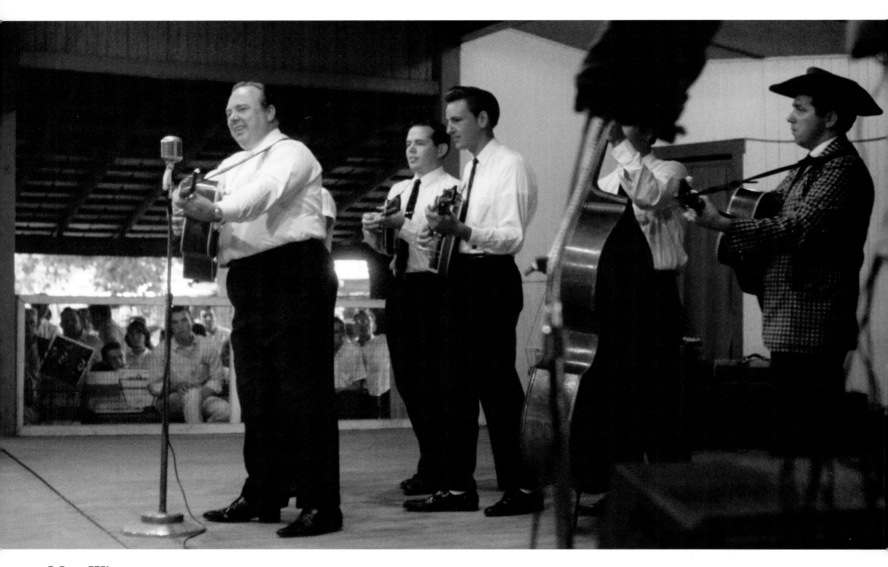

## Mac Wiseman

*SUNSET PARK, 1965*

Known as The Voice With a Heart, Mac Wiseman specialized in maudlin, sentimental weepers like "Jimmie Brown the Newsboy" and "Letter Edged in Black" about crippled orphans and dying sweethearts. Some of these songs dated back to the Civil War.

## Novelty Acts

In the early years, Sunset featured novelty acts and sundry entertainments along with the music. There were wrestling matches and dancing troupes and trained animals and Dare-devil Duffy, who jumped off a pole with a primitive bungee cord. By the 50s and 60s, it was down to a few clowns and the park's last novelty act, The Armless Wonder. Local polka bands were always popular, especially with the local Mennonites who were park regulars. "This was polka country and the people just ate it up."

*Clown with
Mac Wiseman*
*SUNSET PARK
1964*

*Local polka act*
*SUNSET PARK*
*1966*

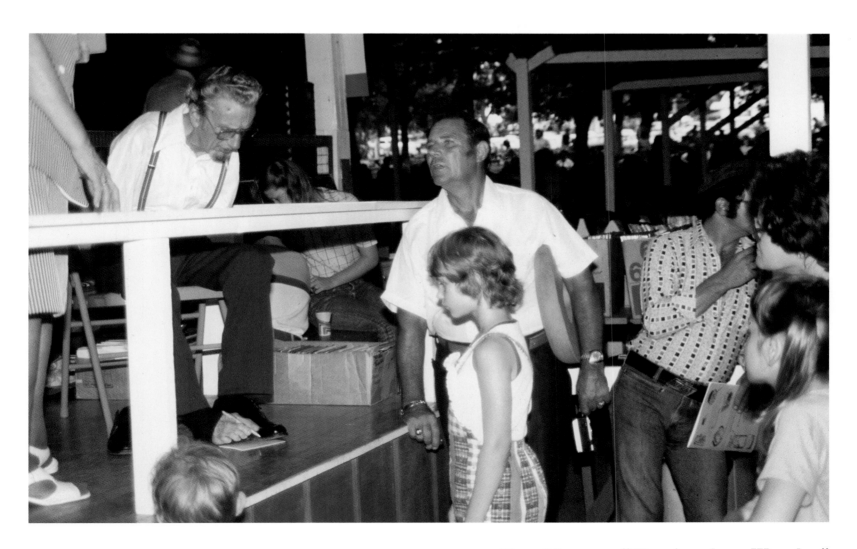

Ray Meyers, "The Armless Wonder"

*SUNSET PARK, 1975*

Ray Meyers, billed as The Armless Wonder, was a local who worked a day job at the Trojan Boatworks factory in nearby Lancaster, PA. Born without arms, Myers could play steel guitar and saw wood and drive nails with his feet, smoke cigarettes with his toes, and for a final crowd-pleasing flourish, pop the cap off a bottle of soda and guzzle it down. "All right, everybody," said the MC. "Let's give the Armless Wonder a hand here!" (Note Leon's daughter Judy, center)

SUNSET PARK

ON ROUTE 1 betw. WEST GROVE & OXFORD, PA.

SUN. JULY 25

JEANNIE C. RILEY

AND THE HARPER VALLEY EXPRESS

POSTERS INC., 539 N. 9th St. Phila., Pa. 19182 • Phone WA 5-2000 (265)

Jeannie C. Riley
*SUNSET PARK*
*1968*

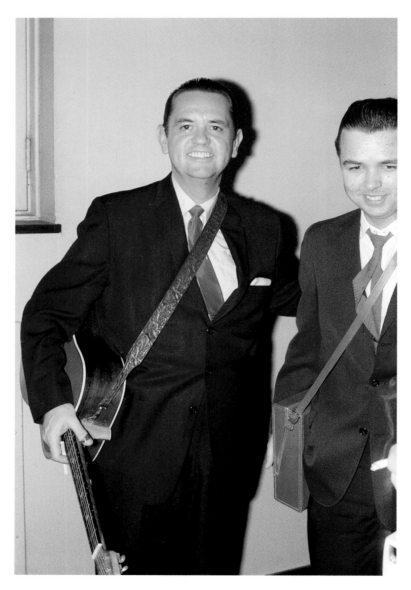

*Merle Travis*
*SHRIVER HALL*
*Baltimore, MD*
*1962*

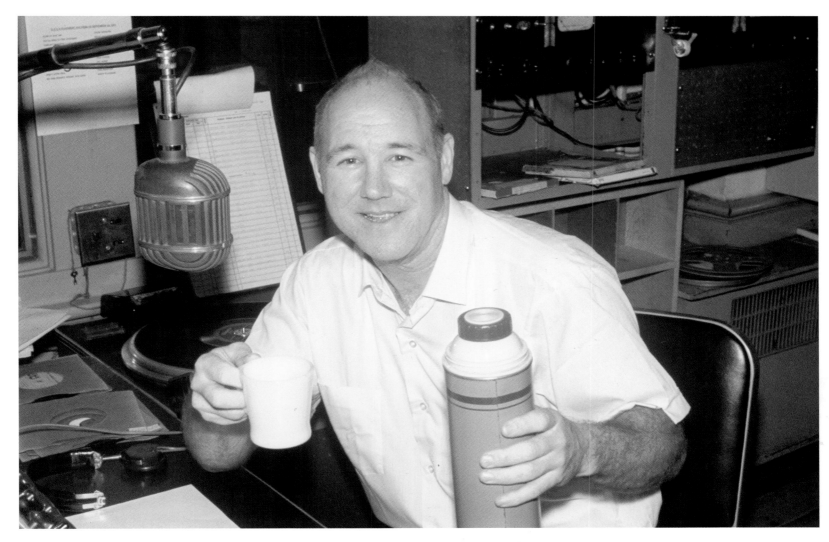

## Lee Moore

*WVVA, WHEELING, WEST VA, 1960s*

Known as the Coffee Drinkin' Night Hawk, Lee Moore was one of the last mass-market deejays playing traditional country on the radio in the '60s. His all-night show on WWVA out of Wheeling, W.VA., on which he peddled items from Last Supper tablecloths to newly hatched baby chicks, was a favorite of truck-drivers, shut-ins and loners like Leon.

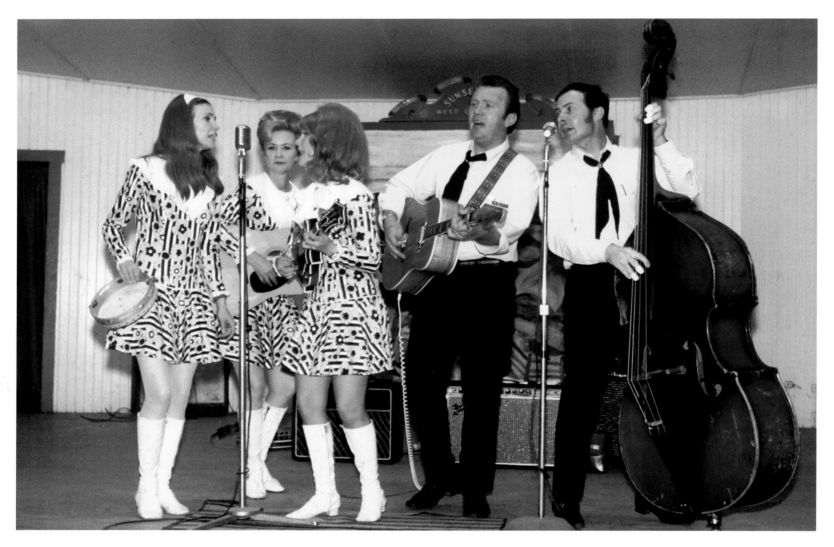

## The Stonemans

*RONI, PATSY, DONNA, VAN, AND JIMMY STONEMAN*

*SUNSET PARK, 1969*

Nashville producers didn't know what to make of the Stonemans, so they tried to make them over. Too country for the country music capital, the Stonemans spent the '60s in a series of costume and musical changes as producers tried to sell them to the folk-music and counter-culture crowd, from Kingston Trio-style matching stripes to beanie-hat and preppy V-necked sweaters to quasi-hippie fringed outfits. It was a sartorial and creative disaster from which the Stonemans never fully recovererd.

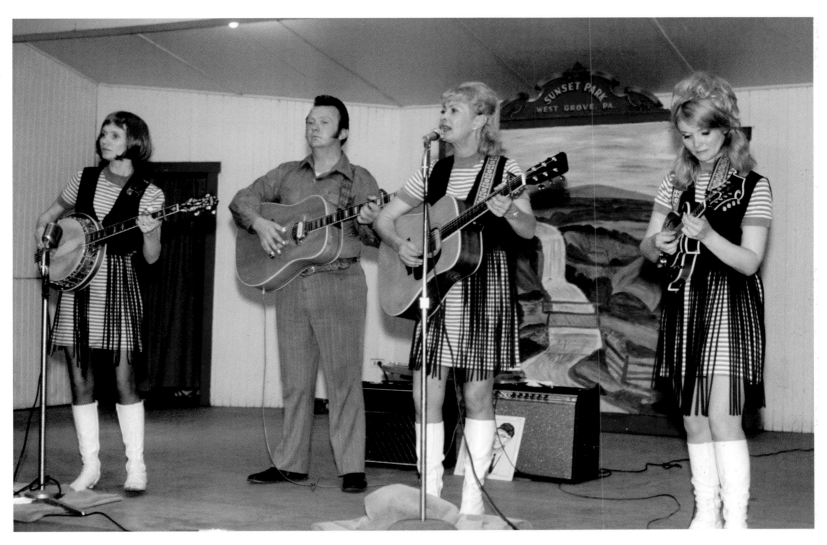

*Roni, Van, Patsy, and Donna Stoneman*
*SUNSET PARK*
*1970*

Roni Stoneman
*SUNSET PARK*
*1970*

Donna Stoneman
*SUNSET PARK*
1970

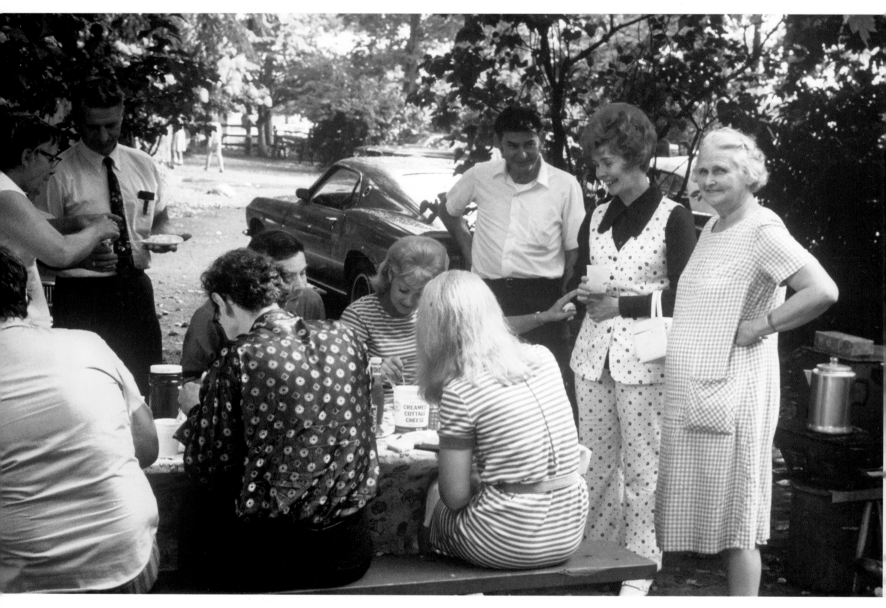

## Patsy and Donna Stoneman eating with fans

*SUNSET PARK, 1970*

"Our kind of fans were so faithful," says Donna. "They'd bring us food and we'd eat with them and it was like a big family gathering. We'd invite Leon to come eat with us. We'd say, 'Come and get a seat at the table and pig out with us.' But he was so busy taking pictures he didn't take much time for meals. Bless his heart."

*Don Reno*
*SUNSET PARK*
*c. 1969*

*Grandpa Jones*
*SUNSET PARK*
*1970s*

# Grandpa Jones

*SUNSET PARK, 1970s*

Louis "Grandpa" Jones was just like one of the family for millions in the long-running country-comedy TV show *Hee Haw*. Before the laughs, though, the Niagara, Kentucky native had rollicking hillbilly hits like "Old Rattler" and "Mountain Dew" stretching back to the '40s. During an appearance at Sunset Park, the summer humidity got so bad his famous false moustache kept coming unglued and falling off his face. He finally just threw it down in disgust and, like the great trouper he was, went on with the show. By then, he really was a grandpa many times over, and his own gray whiskers worked just fine.

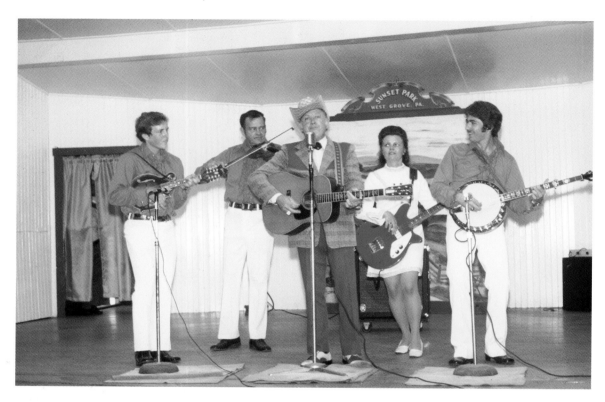

## Jimmy Martin

*SUNSET PARK, c.1970s*

Nobody exemplified bluegrass' high lonesome singing like Jimmy Martin, and he had a mercurial temperament to match the music's extreme emotional pitch. He never realized his lifelong dream of joining the Grand Ole Opry, but he was always welcome at the country-music parks, where his songs seemed to find their proper setting, echoing over the loudspeakers through the trees, into the ravines and far-off fields and lonely places where men go to cry alone: "I'd give an ocean of diamonds or a world filled with flowers, to hold you closely for just a few hours."

# ❖CODA❖

In the '70s, the country-music park circuit petered out, and the old-timey sounds Leon Kagarise loved found refuge at bluegrass festivals where they endure today in increasingly diminished form. Sunset Park was one of the last holdouts, offering faded and fossilized stars until the '90s, but by then Leon had set aside his recorder and camera, the chronicler now turned archivist, or as psychologists would have it, an inveterate hoarder.

For decades, Leon had squirreled away his vast findings, which included not only the reel-to-reel-tapes and color slides and records, but things like busted turntables, tube amps and monogrammed ashtrays from defunct bluegrass bars like The Garden of Eden. (The fact that Leon was a lifelong teetotaler who considered alcohol and tobacco "lethal poisons" did not deter him when it came to collecting.)

In 1998, strapped for cash, Leon unloaded 10,000 78s to a collector who told his friend Joe Lee that buried within the piles in the humble brick rambler on the outskirts of Baltimore were still thousands of LPs and 45s and other treasures untold. That is when Joe Lee came into Leon's world, and it would never be the same again.

Joe Lee is the long-time proprietor of Joe's Record Paradise in Montgomery County, MD, a legendary music shop which has not only survived the demise of the record industry but has danced on its digitized corpse, a place where vinyl junkies from across the globe who come to spend their monthly salaries in a matter of hours.

Joe Lee soon ventured deep into Kagarise's house, scuttling crab-like down paths carved from the piles of records and memorabilia, amazed at the sheer volume of the holdings, stacked floor to ceiling throughout the house. He knew this was the find of a lifetime.

In a row of boxes of old reel-to-reel tapes, Joe Lee saw one marked in a handwritten scrawl: "Johnny Cash, Live 1962, Maryland." Leon threaded the tape on the playback reel and Lee was astonished to hear a pristine, professional-grade live recording of

"Country Boy." There was plenty more, of course, an archive of live hillbilly recordings beyond Lee's wildest dreams

Weeks later, Leon mentioned that he'd shot hundreds of 35mm color slides at the shows he had recorded, but he wasn't sure where the stash was. Gripped by a sort of fever, he searched frantically for the slides to no avail. Then, in the middle of the night, he got of a bed and, with the single-mindedness of a sleepwalker, he headed straight to a clothes bureau nearby and reached underneath for the yellow boxes of precious slides. Here was the pictorial accompaniment to the hillbilly symphonies Leon had recorded in the woods.

For the next several years, Lee and Leon sifted through the contents, and the discoveries continued unabated until Leon's death in 2008, and even after, when family members uncovered an entire room that had been blocked by debris for years.

His final decade gave Leon the recognition that had eluded him all his life. Reporters from *New York Times* and NBC and their big-media brethren came knocking at the front door, which Leon sheepishly cracked open as much as the heaps inside would allow. Despite his embarrassment at the disheveled state of his home, Leon allowed the visitors several steps of entry to see for their own eyes the extent of his cache. His shame was trumped by the pride he now felt that all those years of foraging and collecting had been worth it.

The Country Music Foundation called the archive an historic find, the Library of Congress and Smithsonian salivated, and Leon continued his quiet retired routine. He set up a part-time hi-fi repair business at a North Baltimore branch of Joe's Record Paradise, where his backroom workshop attracted deejays and other young hipsters who came for turntables and vintage audio gear.

A highlight of Leon's final years was a public screening of the color slides. After decades hidden away and nearly forgotten, the photos were now shared by their maker with a live audience. For the most part, Leon sat quiet as a church mouse behind the overhead projector, letting Roni Stoneman help narrate the slide show.

What became quite clear from that evening was the preponderance of photos that focused on Donna Stoneman. The lissome, pretty mandolin whiz with the "happy feet," as Leon put it, was the subject of more images than any other performer. "Well, gosh," said Leon, "the camera liked her, and I guess I did, too."

Donna Stoneman lives in Nashville in the same modest apartment she has resided for decades. She is a self-described "spirit-filled, interfaith" evangelical who preaches and ministers with her mandolin. She still cherishes memories of those bygone days playing music for such dedicated and steadfast fans.

"Leon was such a sweetheart, always so shy and so very, very quiet, but he was always a gentleman. He was a fabulous fan who was always there when we played. I remember how he would always be standing to my left by the edge of the stage. We got to know him well through the years, because we saw him so often. Daddy took a liking to him, and we knew that whoever Daddy took a liking to had to be special."

For Donna, the obsessive nature of Leon's fondness for her and the band was by no means out of the ordinary in those glory years when the Stoneman Family and the Bluegrass Champs ruled the Washington country-music scene. But his photos now occupy a singular and hallowed place in the history of American music. They reveal one man's glimpse of a paradise he found here on earth, at least for fleeting moments of Sundays many summers ago. Now that he's gone, the photos remain as keepsakes of a solitary reverie that looks outward to embrace a whole community where he found a home.

"He did such a beautiful job didn't he?" says Donna "I've been praying for him ever since I heard he passed. I'm sure we'll meet again in heaven."

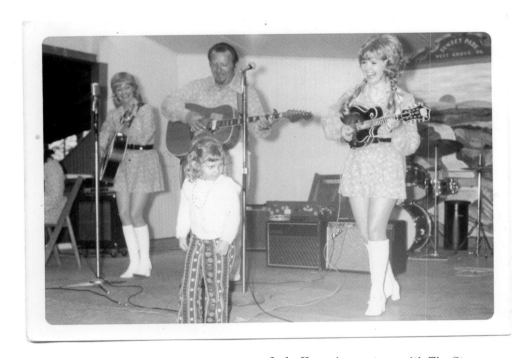

*Judy Kagarise onstage with The Stonemans*
*SUNSET PARK*
*1971*

# ❧ INDEX ❧

# ✻ INDEX ✻

*Leon and his first band (Leon is on the far left), c. 1958*